FENTON
THROUGH TIME
Mervyn Edwards

AMBERLEY PUBLISHING

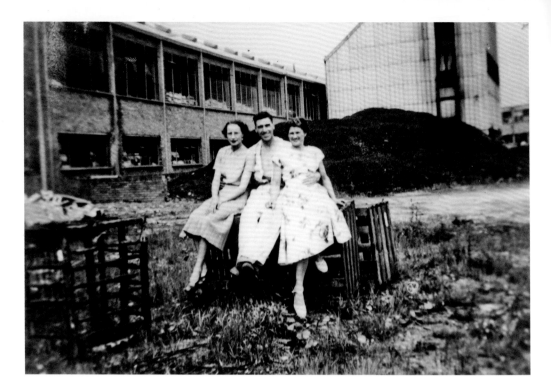

Whieldon's Sanitary Pottery, 1950s
Industry thrived in Fenton. Marie Haywood (1920–2008) is sitting on the right of this trio. Slack for the ovens is seen in the background. Marie also worked at Wedgwood's factory in Etruria and Twyford's in Cliffe Vale. She retired in 1980.

First published 2014

Amberley Publishing
The Hill, Stroud
Gloucestershire, GL5 4EP

www.amberley-books.com

Copyright © Mervyn Edwards, 2014

The right of Mervyn Edwards to be identified as the Author of this work has been asserted in accordance with the Copyrights, Designs and Patents Act 1988.

ISBN 978 1 4456 1732 9 (print)
ISBN 978 1 4456 1744 2 (ebook)

British Library Cataloguing in Publication Data.
A catalogue record for this book is available from the British Library.

Typesetting by Amberley Publishing.
Printed in the UK.

Introduction

It's not as if Fenton doesn't have anything to be proud of. Josiah Spode I and Josiah Wedgwood I were apprenticed to its most eminent master potter, Thomas Whieldon (1719–95). But does Fenton derive a perverse pleasure from supposedly being 'forgotten?'

An 1818 directory of the Staffordshire Potteries gave vignette descriptions of the local towns, but didn't see Fenton as particularly significant, only deserving of a few words attached to the end of the section on Lane End (part of Longton):

> Fenton and Lower Lane and Lane Delph present nothing remarkable, and indeed they may be properly incorporated with Lane-End, of which place they form a kind of suburbs.

Unfairly, author Arnold Bennett incurred censure from Fentonians for making a decision based on euphony. Five Towns, with its open vowel, sounded more appropriate to the broad tongue of the Potteries people than six, and so Bennett omitted Fenton. At the ceremonial opening of Fenton Park in 1924, this outrage was raised publicly by one of the speakers, W. Tunnicliffe.

> He sometimes thought that they owed to Mr. Arnold Bennett a very deep grudge, because he mentioned five towns and left little Fenton entirely outside.

Clearly, Fenton wasn't going to let it lie. There is the account of Bennett's invitation to the annual dinner of Fenton traders, when he would surely have been hauled over the coals. Arnold, replying from London, conveyed that he would be out of the country, but took time to write a letter to the traders explaining why he had omitted Fenton.

Bennett's letter cut no ice and C. R. Martin, the traders' president, gave the following battle cry: 'We must do something that is going to create a noise. We know in Fenton that there is an underdog in the Potteries. We are it.'

Even when Fenton Park was extended, in 1959, Bennett's perceived sin was all too fresh. As Fentonians rejoiced over additions to their new open space, the *Sentinel* newspaper's headline yelled, 'You're not forgotten – Mayor.'

It wasn't just Arnold who 'forgot' Fenton – even the Grand Hotel in Hanley was at it. When the hotel was refurbished, in 1906, four billiard tables were named after the local towns – with Fenton and Tunstall omitted. In 1992, Fenton residents had to fight their corner again. Following the closure of the public conveniences in Victoria Place, Fenton was temporarily the only town of the six without a public toilet.

The closure of the north Staffordshire magistrates' court (Fenton town hall), in 2012, might be seen as a further blow to the town's status. However, it could be claimed that none of the six towns have a more vocal advocate than Alan Gerrard – along with his wife, Cheryl – who own Theartbay art gallery in Fenton. Alan is the passionate cheerleader that Fenton has been crying out for for decades.

Also, as this book shows, Fenton's history as a working town – based around the Potteries' bedrock industries of ceramics and coal-mining – makes it particularly worthy of study.

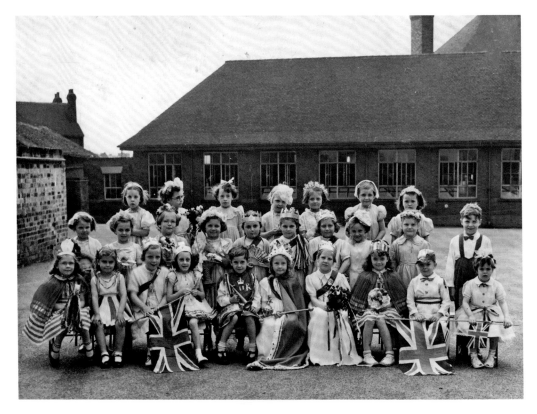

Manor Street School for Girls, 1952
This school photograph shows a class of infants attired for the Queen's Coronation in 1952. Five-year-old Ruth Martin is the queen to the left of the picture, holding the flag. She lived in Stanier Street, and still lives in the street.

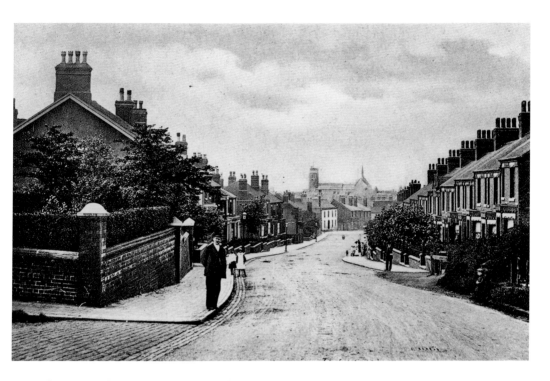

Blurton Road, Early 1900s and Similar, 2014
The above postcard is postmarked 1907. Blurton Road led on to Heron Street. At Great Fenton, part of the area – known as Heron Cross – had been constructed by the late 1870s, possibly spurred by the opening of the nearby Glebe Colliery in the 1860s. Blow we see a section of Blurton Road looking towards the crossings at Heron Cross.

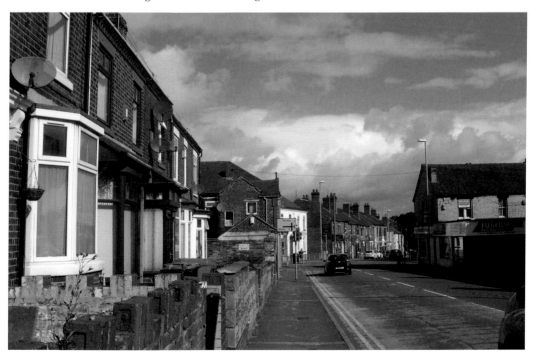

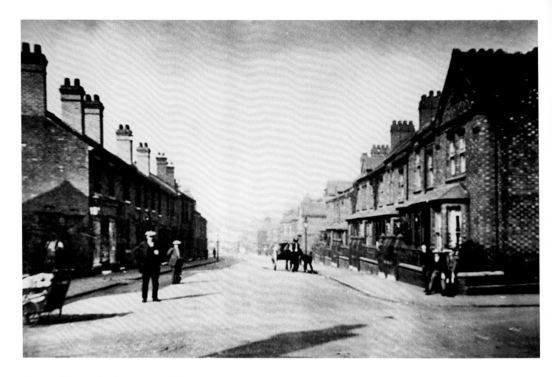

Heron Street, Early 1900s and 2014

The centre of Heron Cross, between Fenton and Blurton, embraces the intersection of four roads – Heron Street, Duke Street, Blurton Road and Grove Road. These are shown very clearly on the simplified plan of Fenton, circa 1960, in the Fenton section of the *Victoria County History Volume VIII*.

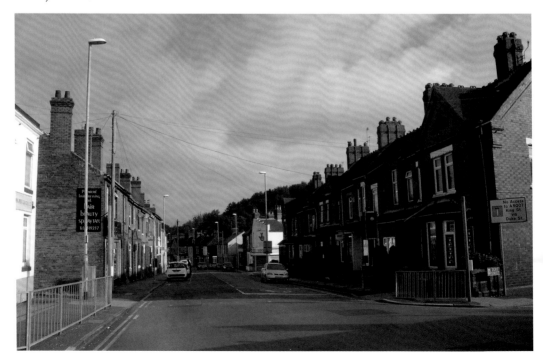

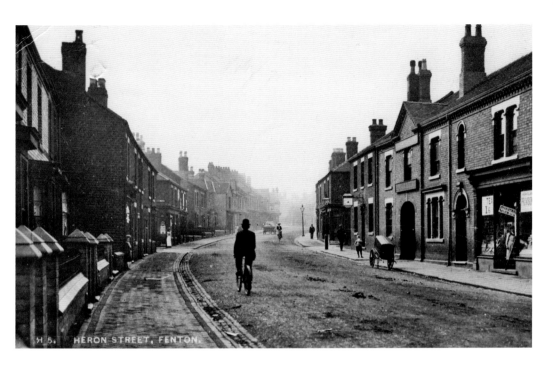

Heron Street, Early 1900s and 2014
The historian Ernest Warrillow recorded that Mrs Elizabeth Wheeldon had kept the tollgate formerly situated at Heron Cross crossroads. Upon marrying, in 1872, she went to live at the tollgate house in Heron Cross, remaining there until the tollgate was removed in 1875. There were two gates in the vicinity: one at the Fenton end of Blurton Road and a busier one at the end of Grove Road, through which much horse-drawn traffic passed to and from the Sutherland Pit.

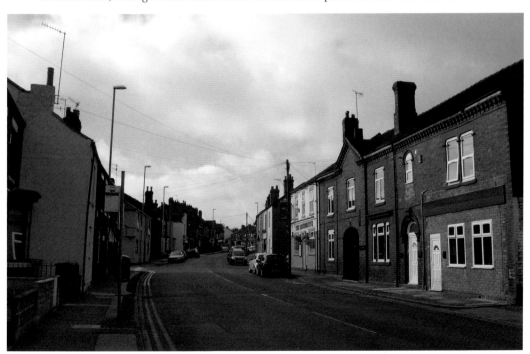

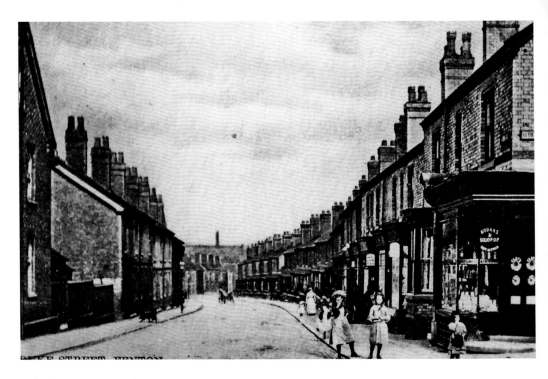

Duke Street, 1910 and 2014

By the late 1870s, a small number of terraced houses had been constructed on the north side of Duke Street, leading from Heron Cross to what was then known as Lane Delph. The upper scene shows a chemist's shop on the corner of Duke Street and Blurton Road. It is selling various perfumes and drugs. A modern-day chemist – Heron Cross Pharmacy – trades at the junction of the two roads.

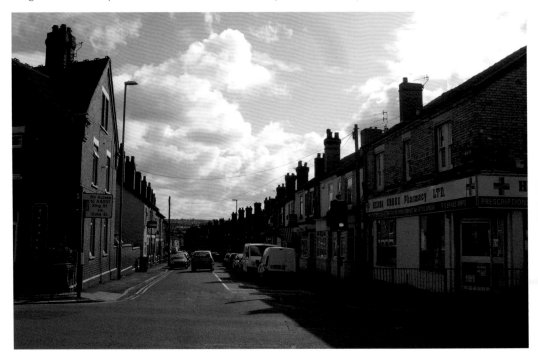

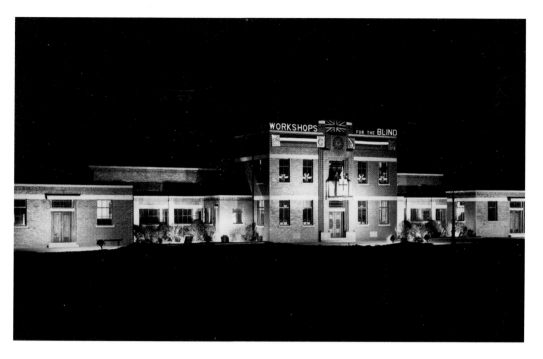

Stoke-on-Trent Workshops For The Blind, 1935 and Site, 2014

A city trade directory, dated 1939, carried an advertisement for the Workshops For The Blind, at the address of High Street East. A description was given: 'Manufacturers of baskets, brushes, mats, bedding, knitted goods, etc. Potters requirements a speciality.' The buildings, which opened on 22 October 1934, had been specially designed to provide all possible comfort to both sexes and incorporated main workshops, with stores and an administrative block, a garage and a caretaker's house. Security barriers presently protect the old site.

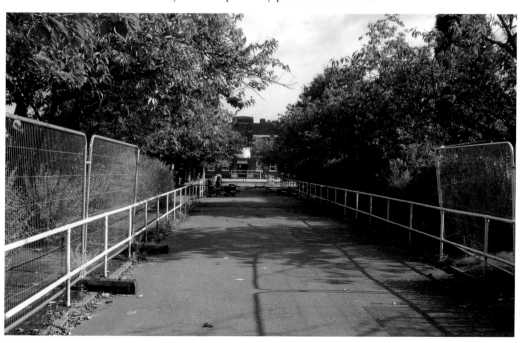

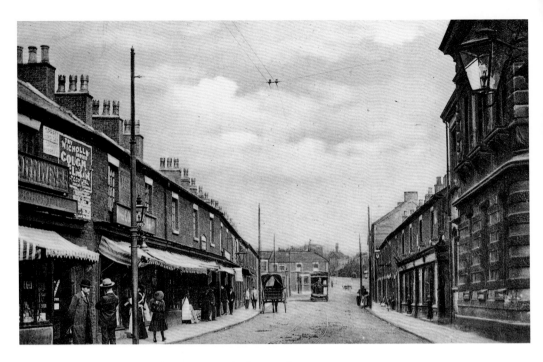

High Street, Early Twentieth Century and City Road, 2014

The view looks towards Longton. On the right, on what is now the corner of Christchurch Street and City Road, can be seen part of the Fenton Athenaeum, built by William Baker IV (1800–65) at his own expense. It was erected in 1853, and incorporated a newsroom and library. The premises was later partly, and then wholly, taken over by the Manchester and Liverpool District Bank, which demolished it, in 1977, and replaced it with new premises.

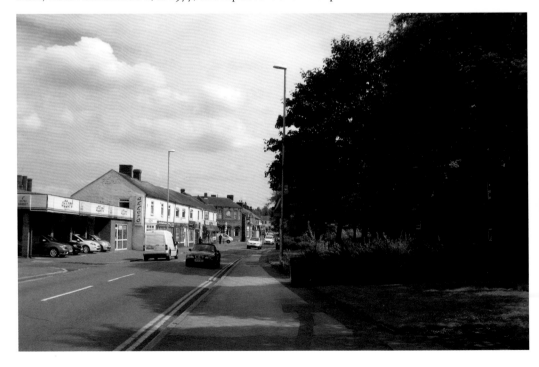

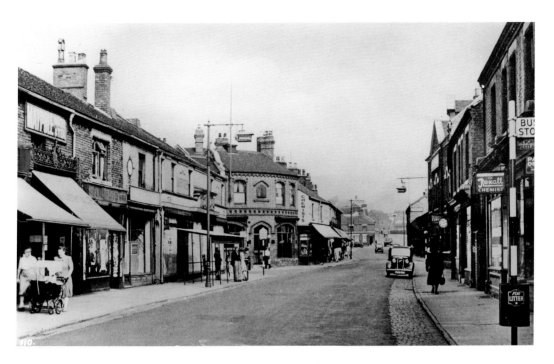

High Street, Early Twentieth Century and City Road, 2014
The ornate building with the curved frontage (*centre-left*) is now the Musician pub, at No. 261 City Road. It stands at the junction with Manor Street, and was at one time a workingmen's club. Steam, and later electric, tramcars once plied the route between Stoke and Longton. In 1908, Mrs Heath of Park Road, Fenton, gave birth to a child while travelling on a tram from Fenton to Longton.

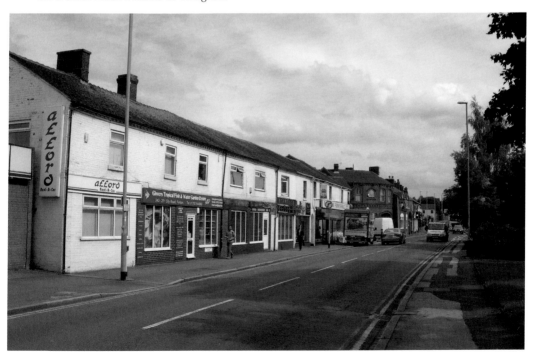

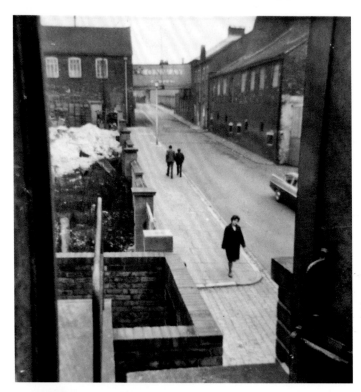

Looking up Park Lane, 1964 and 2014
The Plaza cinema stood at the foot of Park Lane, which was once a busy pocket of Fenton, with Woodend Farm to be found at the top on the right. Beyond that, marlholes underlined the importance of the brick and tile industry in Fenton.

Park Lane Looking Towards Duke Street, 1964 and 2014
As we pass down Park Lane, we approach Duke Street, straight ahead. Early twentieth-century Ordnance Survey maps show the extent of industrial development around Duke Street. In close proximity there are the Wilton Pottery (earthenware) and the extensive Oldfield Brick Works and quarry.

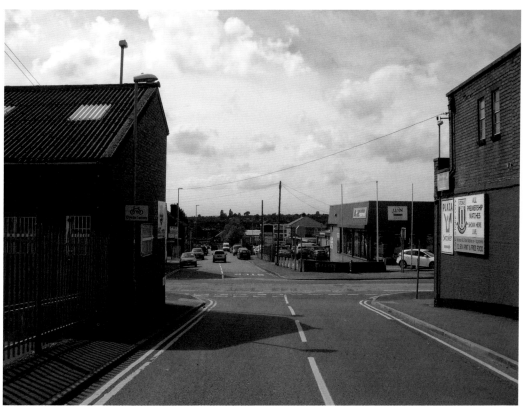

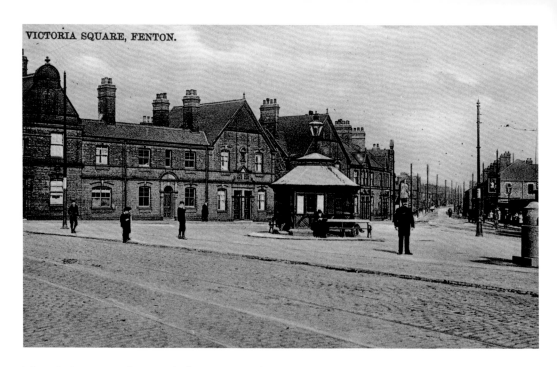

VICTORIA SQUARE, FENTON.

Victoria Square, Early Twentieth Century and Same, 2014

There is a round tram shelter (*above*). The steam tramway in Victoria Square/Place was constructed in 1881; it connected Fenton with Stoke and, shortly afterwards, Longton. The tramline was later electrified, but even then could still be dangerous. In 1904, one chap exited from the Miners Arms pub in 1904 and was knocked down by a tram. The magistrates gave a verdict of accidental death, though conceded that tramcars 'went at a terrific speed' along the main road.

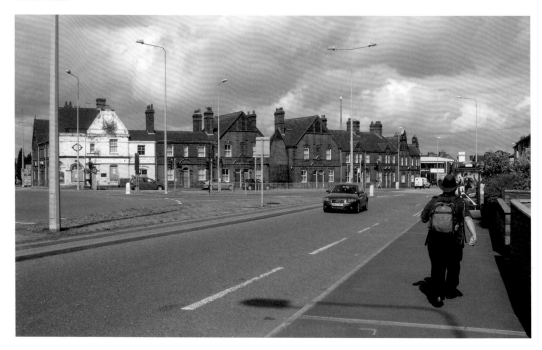

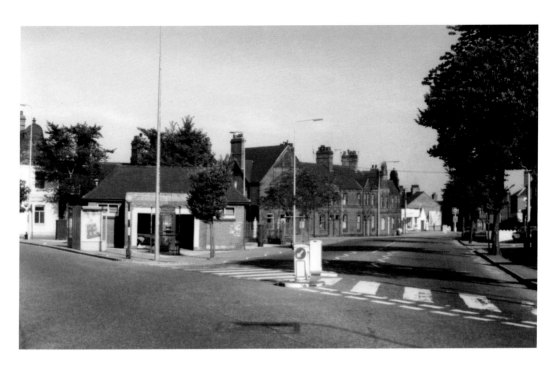

Victoria Place, 1977 and 2014

The ornate properties on Victoria Road in the distance still stand, and were erected by William Meath Baker. Here in 1885, he built thirty houses with decorative frontages and of various sizes. The 1891 census shows many pottery workers lived in these houses. At the junction of High Street and Victoria Road was a large pool owned by Messrs C. Challinor & Co. Fenton Board of Health bought this and filled it in, creating a new square that was named Victoria Square in 1891.

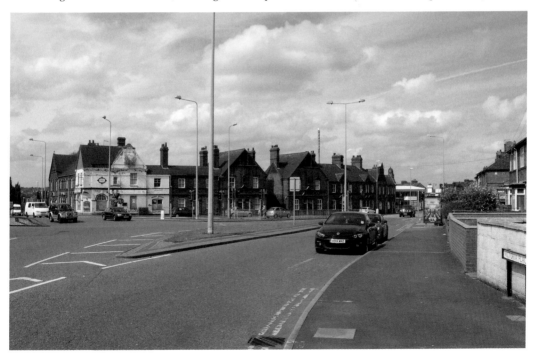

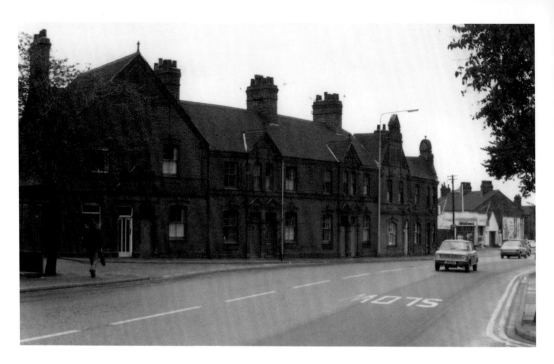

Victoria Road Properties, 1977 and 2014

By the late 1820s, the influential Baker and Bourne families, pottery manufacturers, owned over 100 houses in Fenton as well as the long-demolished Roebuck Inn. Around 1840, John Ward referred to the factories of Bourne, Baker and Bourne, which 'raised the proprietors to the first rank among the eminent and opulent potters who flourished during the bygone portion of the present century.' Ralph Bourne died in 1835.

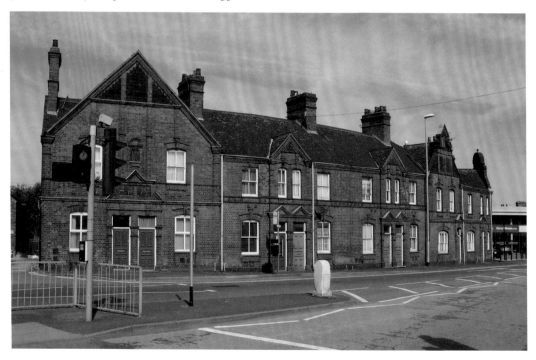

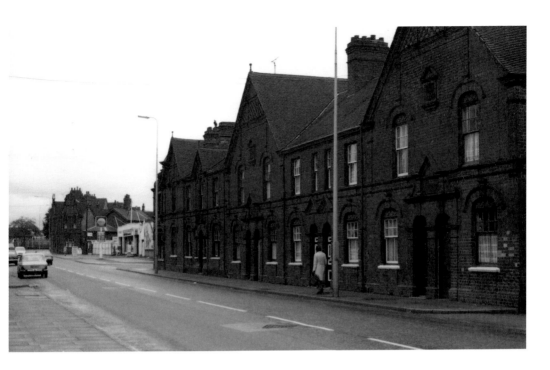

Victoria Road Properties, 1977 and 2014

Victoria Road, leading to Hanley, was built between 1840 and 1842. This is referred to by historian John Ward, writing around 1840: 'A great improvement is in course of accomplishment here, by the making of an entirely new road from Messrs Mason's factory in a direct line to Hanley, which goes over Fenton-low, crosses the Trent a little above a farm called Trent-hay, passes near Joiner's-square, by Eastwood-house, and goes by the Albion Inn into the middle of Hanley.'

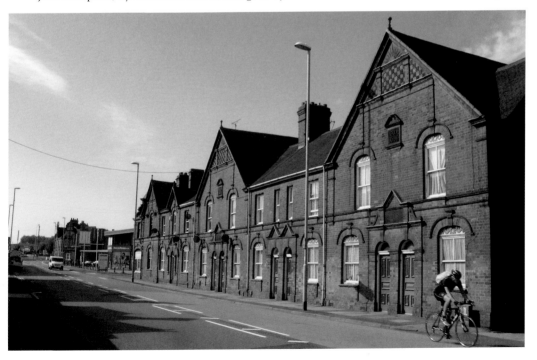

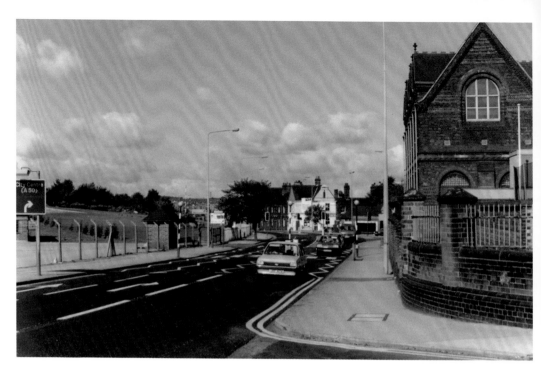

Victoria Place in Distance, 1981 and 2014

Here we look towards Victoria Place from the mouth of Park Street. The school, on the right of the above, was built in what was then Market Street in 1878. In regards to Victoria Wood, Ward added that the road would 'reduce the present circuitous course through Stoke (to Hanley) ... to less than 2 miles.'

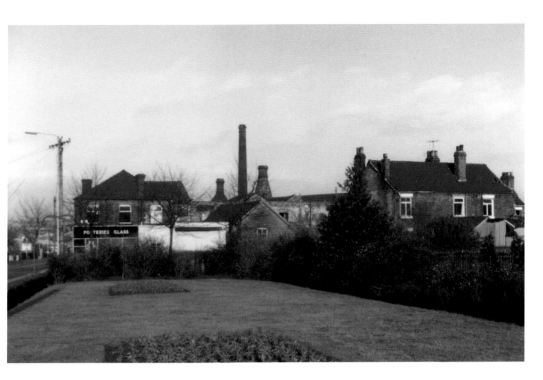

Victoria Road, 1977 and Similar View, 2014

Among those people living in William Baker's houses in Victoria Road, in 1912, were E. H. Latham (butcher), William Salt (engineman), Alfred Hall (engine driver), William Morris (baker), George Deakin (miner), A. E. Thorley (wheelwright) and several people employed in the pottery industry. St Michael's church, built in 1887, was located on Victoria Road.

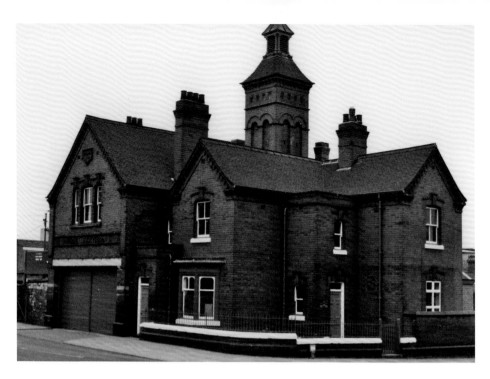

Former Fire Station, 1977 and 2014

Before federation in 1910, each of the Six Towns had their own volunteer fire brigade. In 1859, a fire brigade was established in Fenton when the improvement commissioners acquired a fire engine. The brigade's offices adjoined the former market house that had been offered to them as a fire station but was declined.

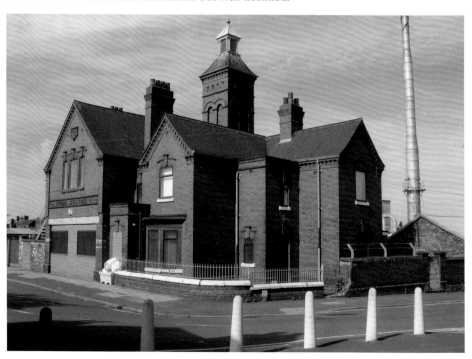

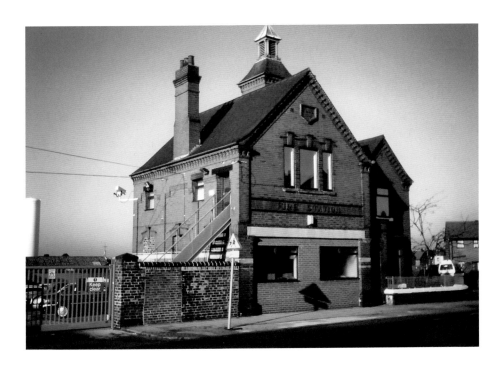

Former Fire Station, 1977 and 2014

By 1865, Fenton had an officer occupying the roles of inspector of nuisances, lodging houses and fire brigade. He resigned in that year, and the last two functions were transferred to the Inspector of Police. This fire station, in Fountain Street, was located next to Baker's Mill (Flint etc.) on its right-hand side. The station had a bell incorporated, for raising the alarm. We note that 'FUDC [Fenton Urban District Council] 1909' is displayed on the frontage.

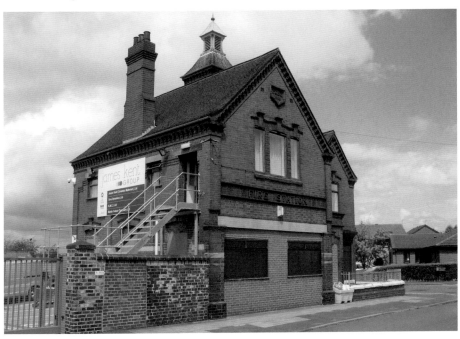

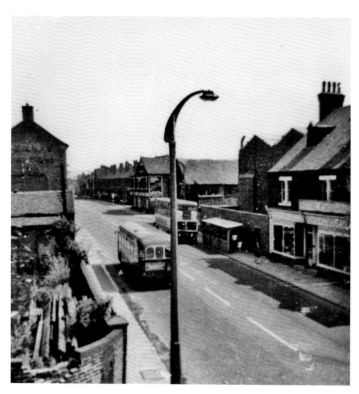

King Street Viewed From Plaza, 1964 and Similar, 2014
King Street forms a stretch of the main road that passes through Fenton. This was the old Newcastle–Uttoxeter Road, turnpiked under an Act of Parliament in 1759. By 1832, there was a tollgate operating at the junction of the present City Road and Napier Street. In 1875, the road was disturnpiked.

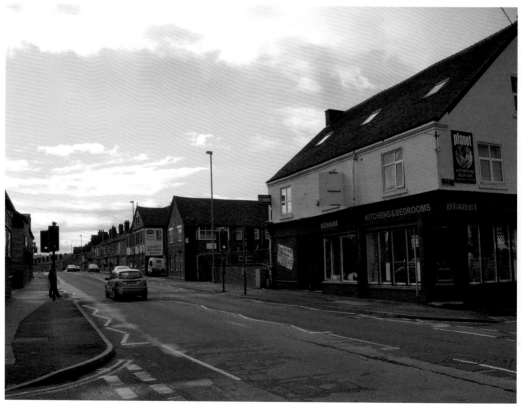

King Street/Duke Street Viewed from Plaza, 1964 and 2014 This main road was a thoroughfare that linked what were Little Fenton (Fenton Vivien), Lower Lane and Lane Delph, and the Foley (near the Longton border). These and other place names date from the time when Fenton was effectively a collection of separate villages. Notwithstanding this, Fenton was known by the 1830s for 'its many large potteries and handsome houses.'

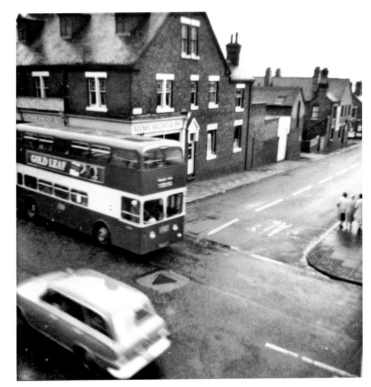

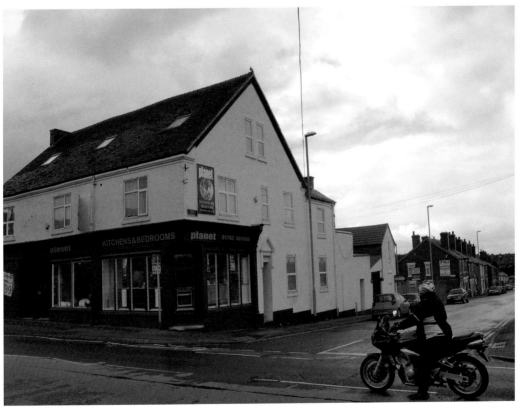

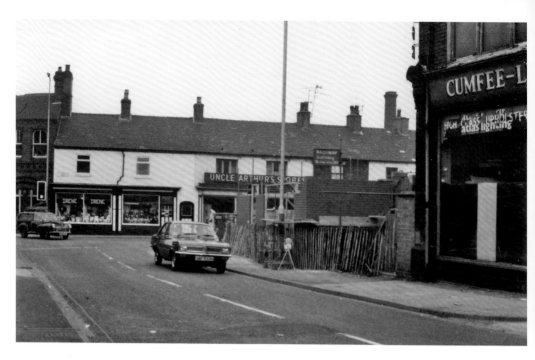

Christchurch Street Looking Towards City Road, 1977 and Same, 2014
According to some observers, the present City Road has merely encouraged people to bypass
Fenton. In 1961, Mervyn Peake recorded, 'Fenton, the smallest town, is the least able to stand on
its own two feet – the least like a separate town, one might say. It isn't really much more than
a connecting link in the urbanized chain.' The road is also mentioned by Bill Morland in 1978:
'In Fenton, Stoke is left behind and Longton is sprung up before Fenton seems to have been.'

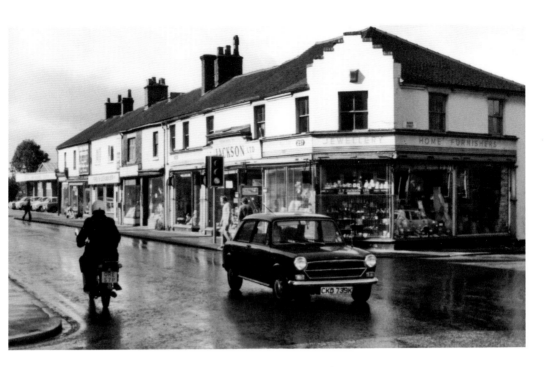

City Road and Manor Street Junction, 1977 and Same Site, 2014

J. T. Jackson, jeweller, clothier and furnishers stood in City Road, as shown. Several other businesses may be remembered as trading on City Road during this period. A 1972 trade directory mentions Yates and Son's cycles, Dale and Vincent's florist, Mrs E. Dale the corsetiere, the Cosy Expresso Café, Frank Myatt the greengrocer, and G. J. O'Donnell the dental surgeon. King Street businesses included Fenton Furnishers Ltd, K. V. Horrobin's drug store, W. H. Ryles Haulage, Smitten's newsagents and T. A. Building Services Ltd.

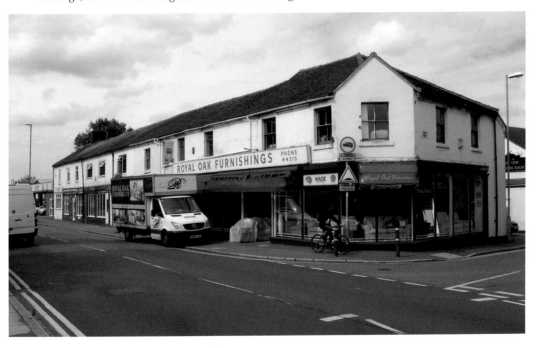

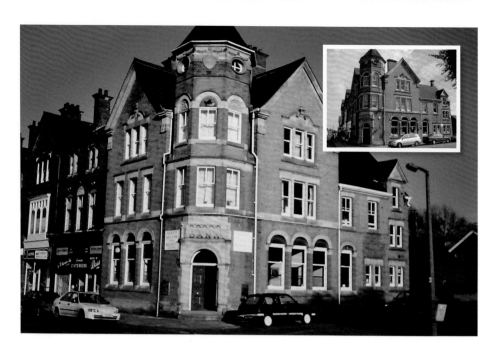

Former NatWest Bank, 1994, Theartbay gallery, 2014 and Sid Kirkham (*inset*), 2014
Theartbay is a community focused gallery, exhibition space and fine art publishers, run by Alan and Cheryl Gerrard. Sid Kirkham's art is well known in Stoke and beyond. Once an employee in the tyre-making industry, Sid later forged a career as a successful artist after buying a teach-yourself-to-paint kit. Sid has depicted various aspects of the city's past, including bottle ovens and factories, the furnaces at Shelton Bar, and football matches involving local clubs Stoke City and Port Vale.

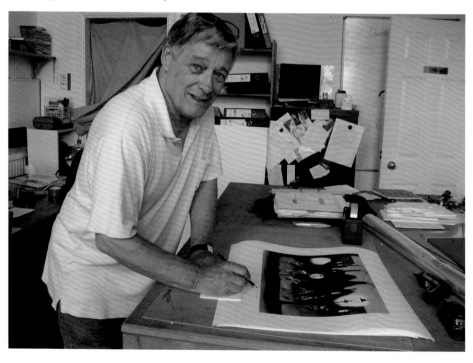

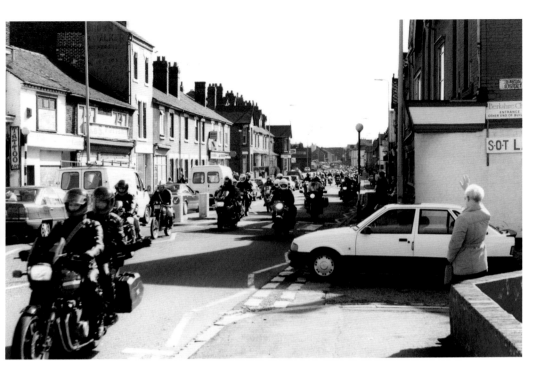

King Street/Baron Street Junction, 1980s and 2014
Numerous motorcyclists make their way down King Street, as we look from the corner of Baron Street. The Potters 'Arf race competitors ran in the other direction as they made their way from Hanley as part of the 2014 event, in which the author competed.

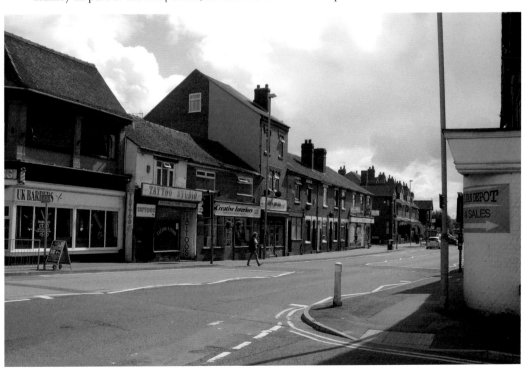

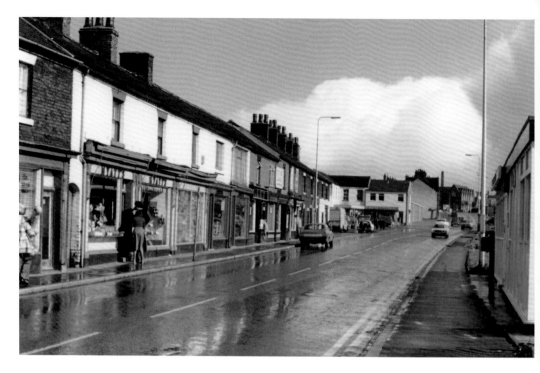

City Road, 1977 and 2014

The premises of Frank Myatt, greengrocer at No. 232 City Road, is clearly seen above. Present-day traders shown in the modern scene are the Potteries Gas Services & Rob DeCecco Fireplaces and the Sandwich Box. In the distance we can see the premises of A. J. Philpott, on the corner of Fountain Street.

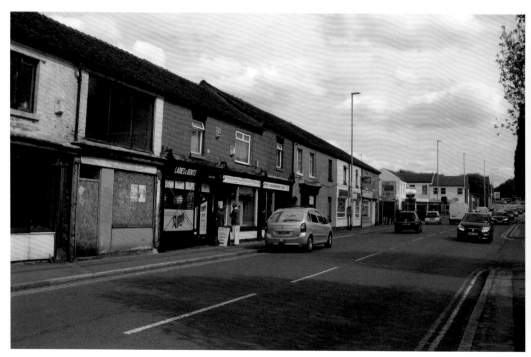

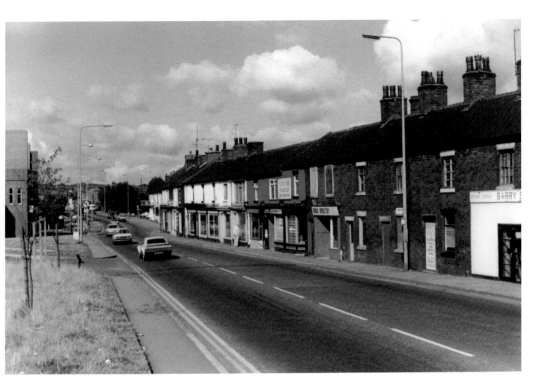

City Road, 1981 and 2014
The premises with the salmon-pink upper storey was the City Road Garage. In the present-day scene, the shop of T. & M. Redfern Ltd is conspicuous.

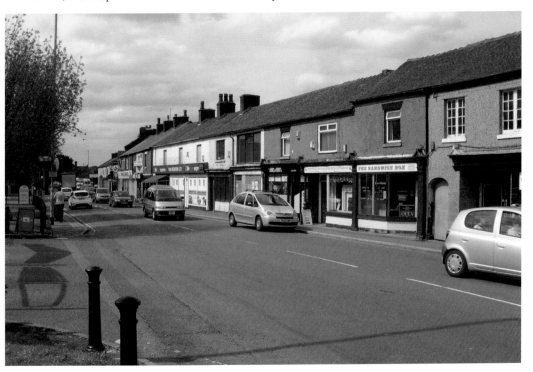

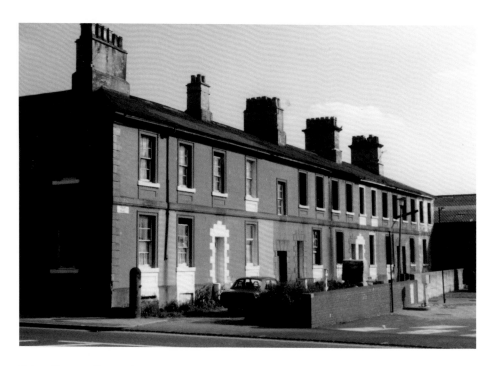

Foley Place, 1980s and 2014

Foley Place, on King Street, is situated on the boundary with Longton. This middle-class housing is likely to have been built in the 1830s or 1840s, and is in the late Georgian style. There were originally eleven houses and an inn. The Foley Arms Hotel is closed at the time of writing. The elegant houses in Foley Place once overlooked a garden area. This is presently occupied by a garage and petrol station.

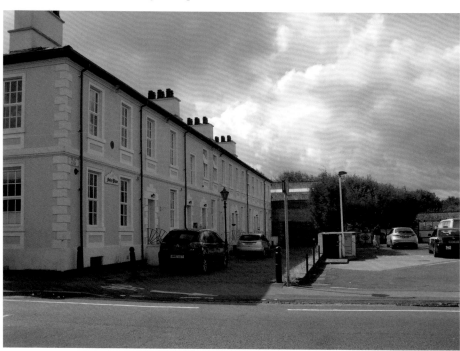

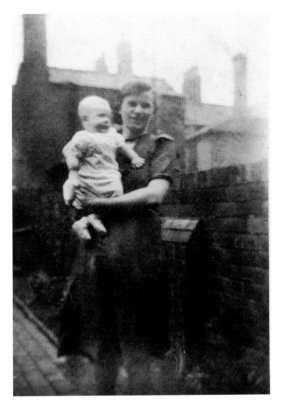

No. 24, Hardinge Street *c.* 1947, and Hardinge Street, Date Unknown
Time marches on, as these two views show. The older, courtesy of Margaret Bould, shows her auntie, Ann Cashbolt, with her baby, Brian, in her arms. Note the humble backyard of a typical working-class property. The solid brick wall overlooks a blue-brick path that would have led down to a bottom gate. Such paths as these were once commonplace, underlining the prosperity of the brick and tile industry in the potteries and the availability of local clay. There were several quarries in Fenton, and we are reminded that the Glebe Colliery had an attached brickworks.

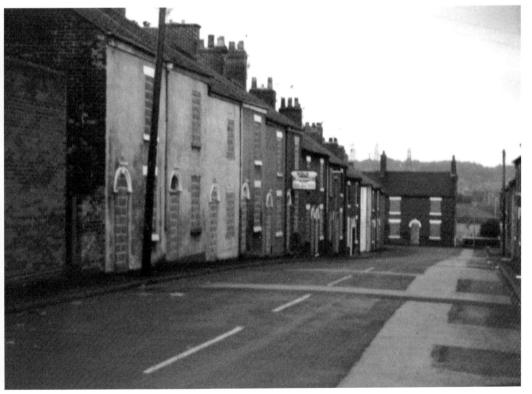

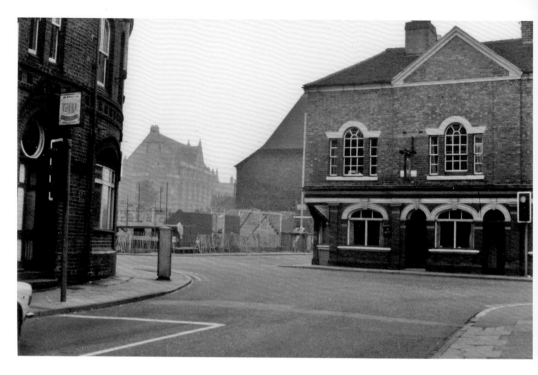

Manor Street/ City Road Junction, 1981 and 2014
The older scene has a CIU-affiliated working-men's club on the extreme left, now the Musician pub. The contrast between the Royal Oak pub before and after its rebuilding is striking. Directly beyond Manor Street is Christchurch Street.

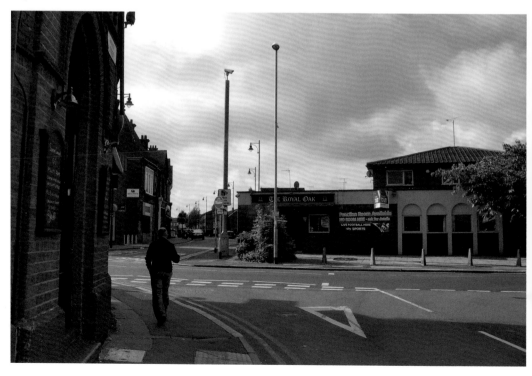

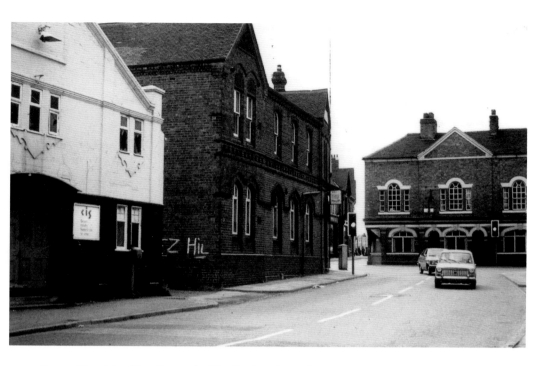

Manor Street Looking Towards City Road, 1980 and 2014
On the extreme left is the former Royal Picture House, which opened in March 1913 and closed in April 1960, becoming Roberto's night club. The Royal Oak could boast of a pedimented gable and three Venetian windows. Such windows often adorned factory frontages, and churches such as Bethesda in Hanley. However, this type of window in a pub frontage was quite rare. The hostelry was demolished in 1980, its replacement opening in 1981.

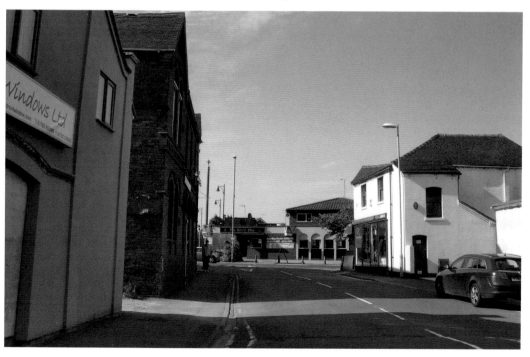

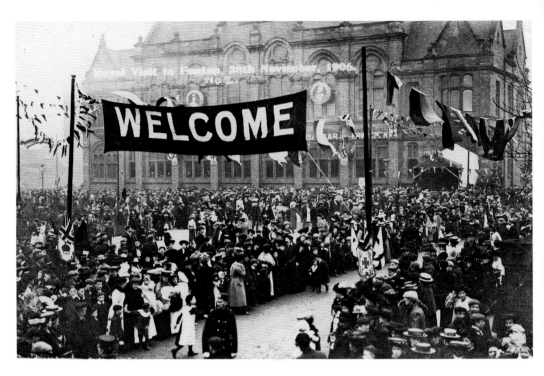

Town Hall and Royal Visit, 1906 and Town Hall, 2014
The Royal Visit to Fenton, on 28 November 1906, was by HRH Princess Henry of Battenburg, the youngest child of Queen Victoria, and sister to King Edward VII. They opened a bazaar in the town hall. The front of the town hall was draped with a promotional banner: 'The Fenton Church Grand Indian Bazaar Now Open.'

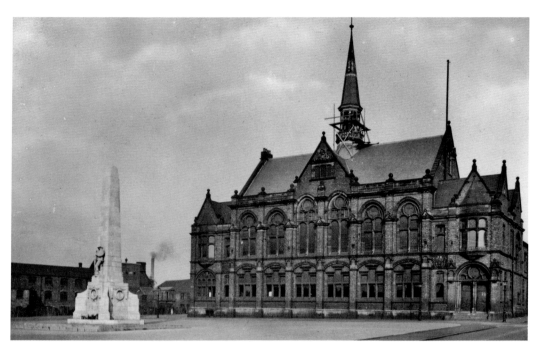

Town Hall and Cenotaph, Early Twentieth Century and 2014
Fenton town hall was described in one local newspaper as a 'suite of public buildings' when it opened in December 1889. It overlooked a new square. Pottery owner William Meath Baker (1857–1935) funded the building of the town hall, and then leased it to the Local Government Board of Health – the governing power in Fenton at that time. In 1894, Fenton constituted an urban district and, in 1897, the Urban District Council bought the town hall from Mr Baker.

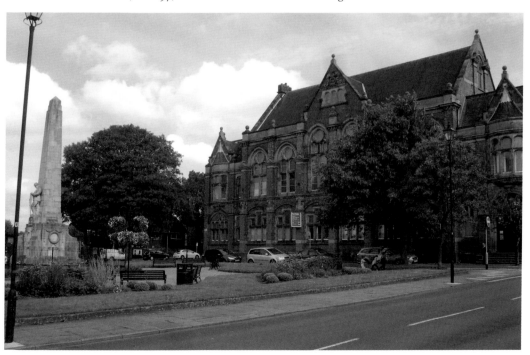

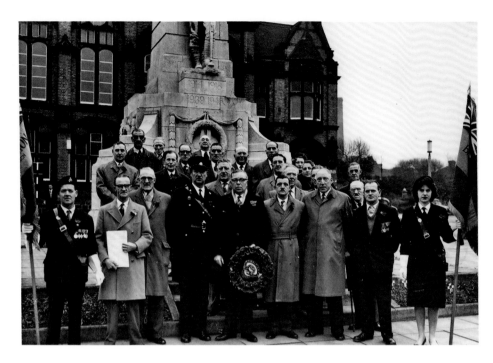

Albert Square and Cenotaph, 1964 and Same Site, 2014

Many community events have been held at the town hall over the years. It often played host to Fenton's annual old folks' tea party, a treat for the aged, funded by voluntary contributions. At the 1908 function, the senior citizens were joined by forty workhouse inmates. On departing, the elderly ladies each received a quarter of tea and each gentleman 2 ounces of tobacco.

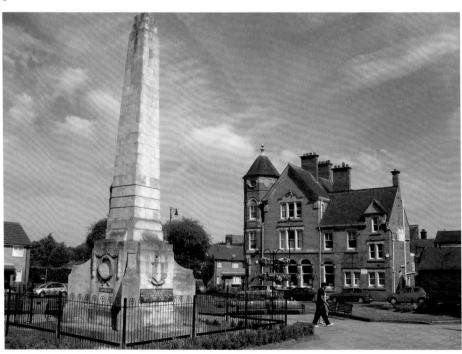

Town Hall Party, Date Unknown and Human Chain, 2014
In 1968, the town hall was handed over by Stoke-on-Trent City Council to the Ministry of Justice in 1968, and in recent times, the building has faced an uncertain future, with the Ministry of Justice considering selling it to a private developer. In August 2014, campaigners formed a human chain around the town hall in order to show strength of feeling against proposals to sell the building to the highest bidder. A war memorial containing the names of 498 Fentonians is built into the interior.

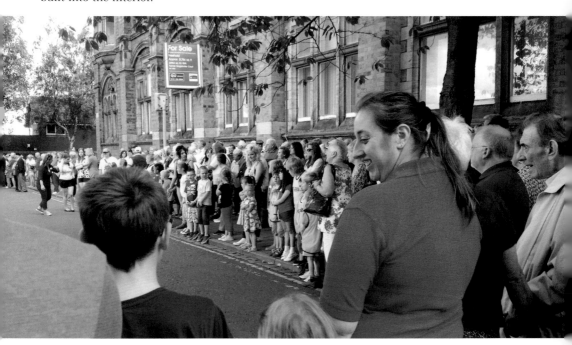

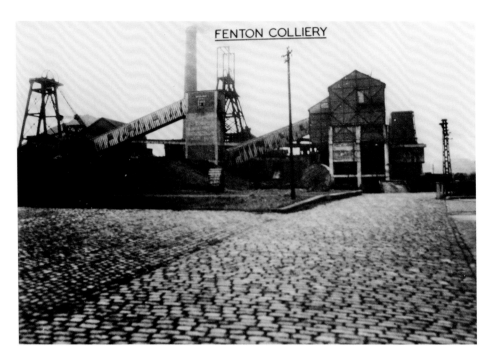

FENTON COLLIERY

Glebedale Colliery, Probably 1940s and Glebedale Park, 2014
Glebe Colliery – which had adjoining brickworks – operated from 1865. Charles Challinor, the managing director of the colliery, met a horrific death in 1893. He was found decapitated in the engine room of the colliery, his head lying under the machinery, which was still working, his body on the footway below the machine. Charles was also head of the firm C. Challinor & Sons, of the Fenton Ironstone Company, and connected with numerous other firms.

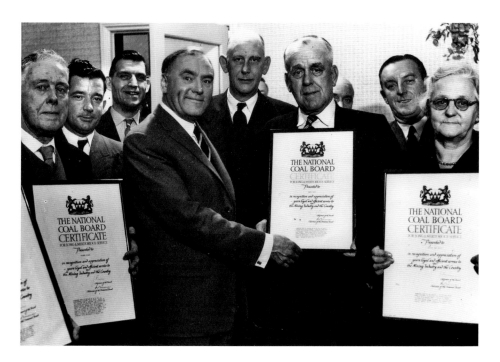

Glebe Colliery, 1960 and Glebedale Park, 2014

This shows a presentation of long service certificates at Fenton Colliery by W. Cumberbatch, group manager. Jim Ball, manager at Fenton Colliery, is to the right of Mr. Cumberbatch. On the extreme left is Willie Nelmes, father of Audrey Worgan. He started in 1907 in New South Wales and worked at Stafford Colliery, Fenton, as a faceworker between 1916 and 1931. He worked at Glebe Colliery, as a wharf attendant, from 1931 until his retirement in 1960.

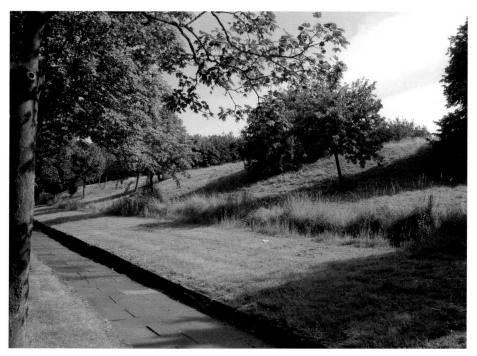

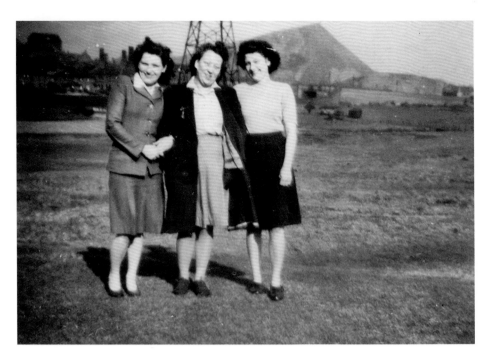

Lido With Spoil Tip to Rear and Glebedale Park, 2014

On 13 June 1963, an explosion occurred at Glebe Colliery, caused by coal dust. It killed three men. The colliery operated until October 1964. The proximity of mining operations in Fenton is seen in the above photograph, which shows a colliery spoil tip overlooking the lido, a favourite area of recreation for Fentonians. Since its closure, the Glebe Colliery spoil tip has been reclaimed, and Glebedale Park is a pleasant, open space to walk around.

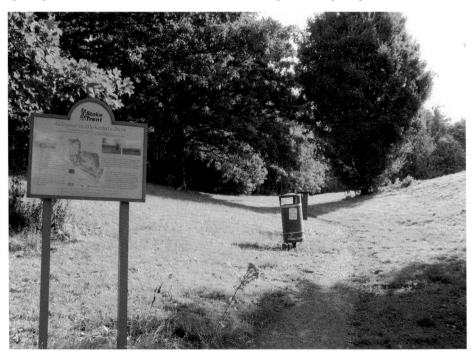

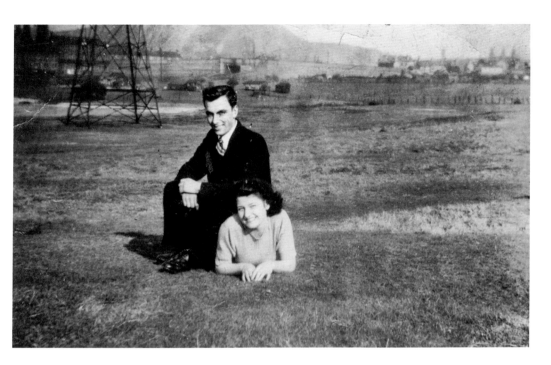

Lido with Spoil Tip to the Rear and View from Glebedale Park, 2006
Here is another view of the lido and mining activity in the background. The strength of the mining community in Fenton was underlined by the staging of annual miners' fêtes and galas by the Fenton Lodge of the North Staffordshire Miners' Federation. This would be preceded by a march through the main streets and would offer races, band music and trapeze and acrobatic performances. Proceeds went to lodge funds.

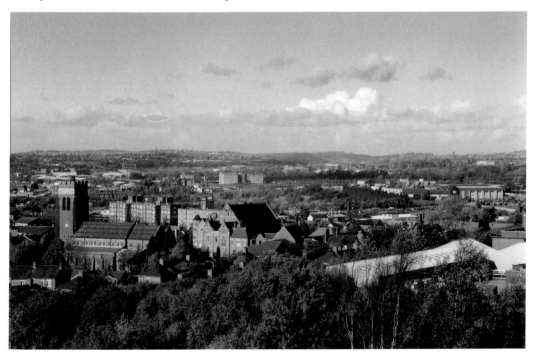

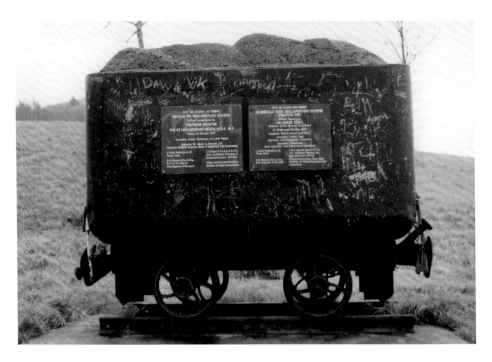

Glebedale Park Pit Tub, 1993 and 2014

The pit tub incorporates two plaques. One informs us that on the same day that Prime Minister Edward Heath opened the newly-reclaimed Westport Lake in October, 1971, the reclaiming of the Glebe Colliery spoil was set in motion. The second plaque reveals that the Glebedale Park Reclamation Scheme (Fenton Tip) was officially opened by Derek Ezra, Chairman of the National Coal Board, on May 2 1973. Cllr Bill Austin was lord mayor at the time.

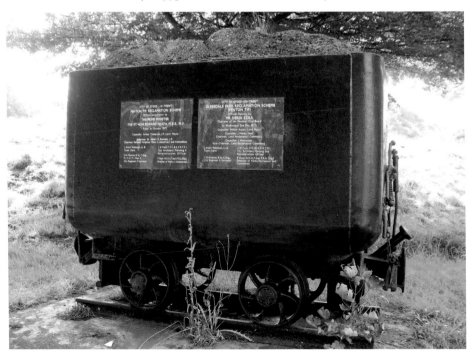

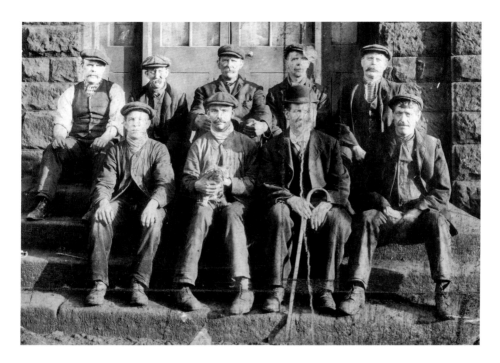

Kemball Colliery, 1920s and Site, 2014

Kemball Colliery operated from 1876 to 1963. In 1943, it became a training pit for new recruits to the mining industry. Jack Hall, the grandfather of Dave Walklett, is on the far right of the front row of a group of men who stand outside one of the engine houses at the colliery. On the back of Dave's photo is written, 'P. & K. Engineering Dept.' The present Holiday Inn stands on part of the former Kemball Colliery site.

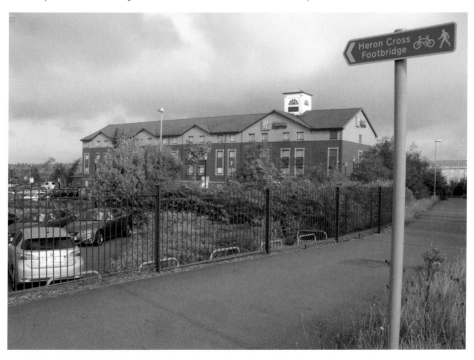

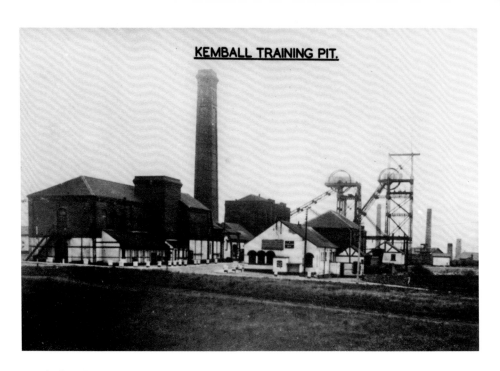

Kemball Colliery, *c.* 1940s and Site, 2014
When the training centre opened, it was the objective that any newcomer to the district's pits – youths, volunteers, or those directed by the Government – should receive preliminary training before going underground as miners. Many wartime Bevin Boys were trained at Kemball. The centre was the first of its kind to be set up in any coalfield. Though underground operations ceased in 1963, the site was used for surface training until 1989.

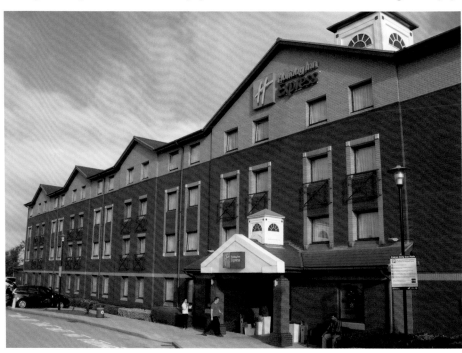

44

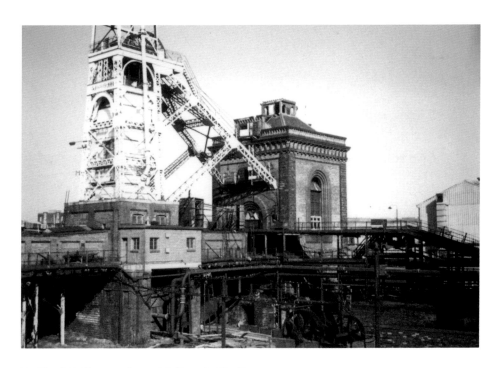

Stafford Colliery, 1969 and Britannia Stadium, 2013

The colliery was often referred to as Stafford Coal & Iron, or Great Fenton Colliery or Stafford No. 2 – Stafford No. 1 being Kemball Colliery. It was a familiar site to North Staffordshire Railway commuters travelling between Stoke and Trentham. It was sunk in 1873 by the Duke of Sutherland, one of whose seats was nearby Trentham Hall. In partnership with him were Messrs Pender, Charles Homer and John Bourne.

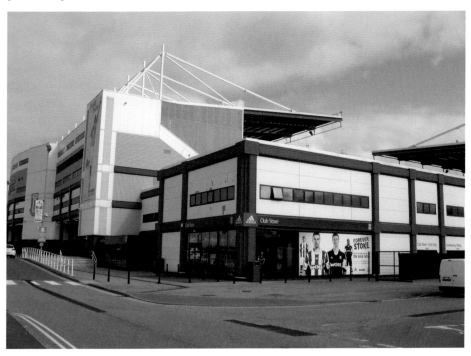

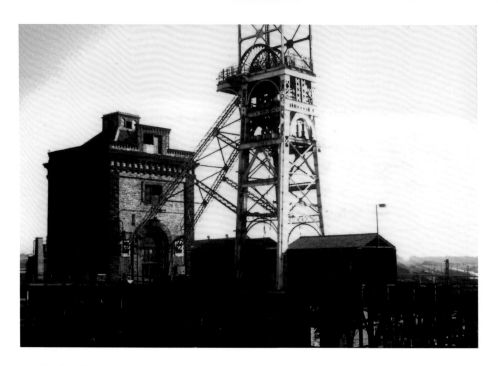

Stafford Colliery, 1969 and Britannia Stadium, 2013
Eight men died at the colliery on 10 April 1885, in an explosion in the Sutherland and Homer pits. These were downcast and upcast shafts respectively, and were both 600 yards deep at the time. The accompanying ironworks dated from 1882. By 1902, the pit employed 1,383 men underground and 309 surface workers. The pit closed in 1969 and is pictured here in its final year by Alan Salt. Stoke City's Britannia Stadium occupies much of the old colliery site.

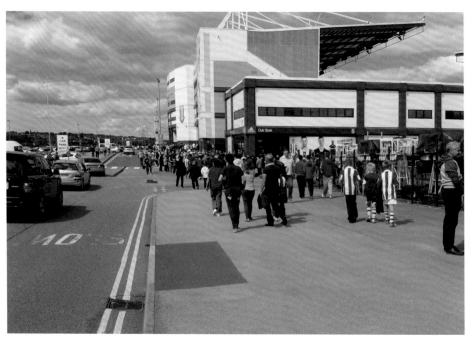

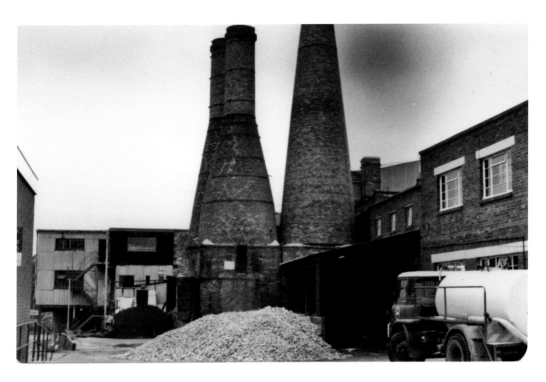

James Kent, Fountain Street, 1977 and 2014

Three calcining ovens appear here, at what was once a factory site belonging to the powerful Baker family of potters. The ovens date from around 1900 and are Grade II listed. The present James Kent (Ceramic Materials) Ltd is a supplier of bespoke and tailored products for the glass, ceramic, dental and nuclear refractories, and recently the vitreous enamelling industries.

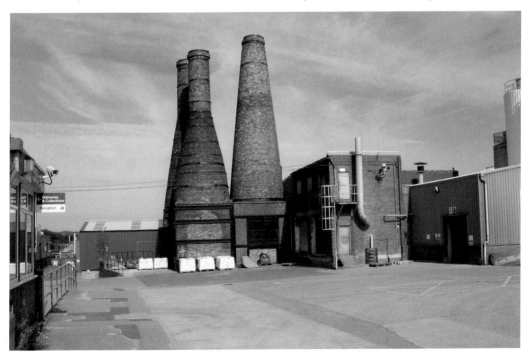

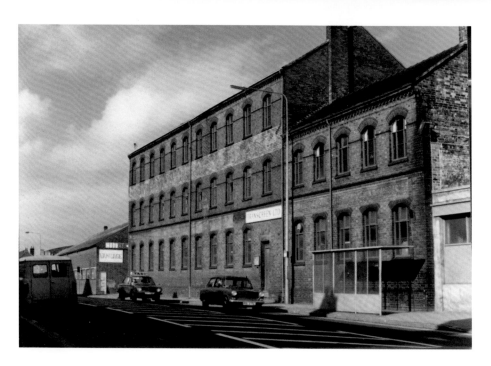

Former John Edwards Pottery, King Street, 1982 and Same Site, 2014

Information in the *Encyclopaedia of British Pottery and Porcelain Marks* conveys that John Edwards and & Co. commenced potting at Longton around 1847, and moved to Longton around 1853. It was one of the fourteen Fenton pottery manufactories listed in *The Staffordshire Potteries Directory* for 1868, specialising in china and earthenware. The premises were used as a tea warehouse in the 1960s. It was demolished in March 1982.

Heron Cross Pottery, 1993 and 2014
This pottery was built by brothers Thomas and William Hines in what was Gordon Street (which became Hines Street in the 1950s). The pictures show the building's frontage, in Chilton Street, looking from Hertford Street. It formerly had a third storey, but this was removed following a fire. There were once seven bottle ovens on site. In the 1980s, an imaginative scheme was devised to save the premises from imminent demolition by turning it into a visitor centre, which incorporated the Frit Kiln Restaurant, named after the site's remaining frit kiln. 'Fritting' was a process for making glazes, and a life-saving innovation in the pottery industry, as it reduced the vulnerability of the 'dippers' (glazers) to lead poisoning.

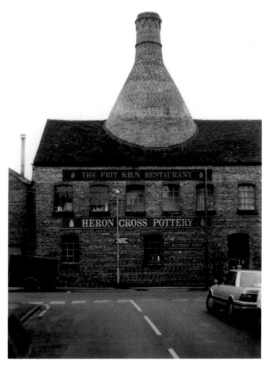

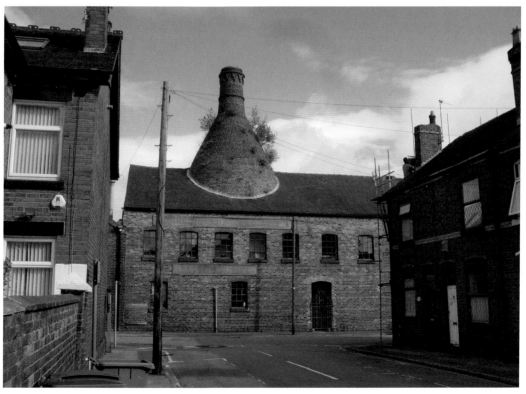

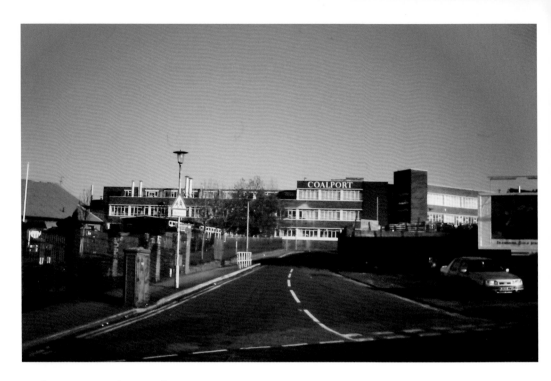

Coalport, 1994 and Same Site, 2014
In 1967, the Wedgwood Group absorbed the pottery company of Coalport, moving the brand, in 1985, to the Minerva Works in Park Street (*above*). The Crown Staffordshire China Company had owned the premises from 1948 up until this date, extending the factory in 1950. The site of the extensive works is now occupied by new housing.

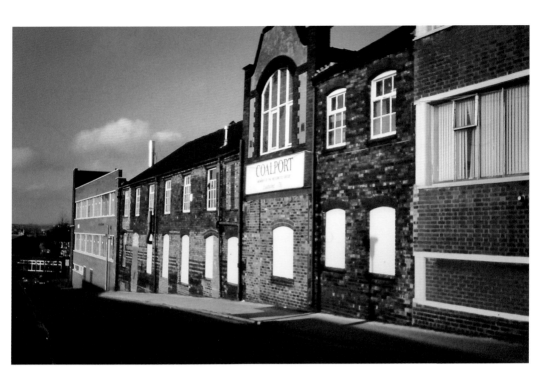

Coalport, 1994 and Same Site, 2014

In 2000, Coalport was transferred to purpose-built premises at the Wedgwood factory in Barlaston, with the Minerva Works being demolished in 2001. Minerva was the Roman goddess of intelligence, and of the handicrafts and arts. She had a shrine on the Aventine in Rome that was a meeting place for guilds of craftsmen.

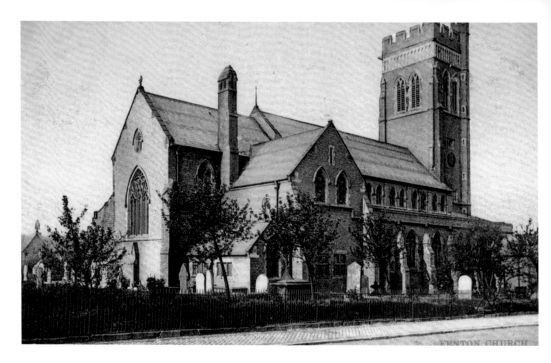

Christ Church, Date Unknown and 2014

Our section on churches and schools begins with a postcard photograph postmarked 1906. The original Christ church was erected in 1839, largely due to the beneficence of pottery manufacturer John Bourne (died 1835). He left £3,500 for its erection and maintenance. However, mining subsidence made it necessary to rebuild Christ church, and the present edifice was erected in 1890. The architectural historian Pevsner describes it as 'the magnum opus of Charles Lynam of Stoke – magnum, however, only in size.'

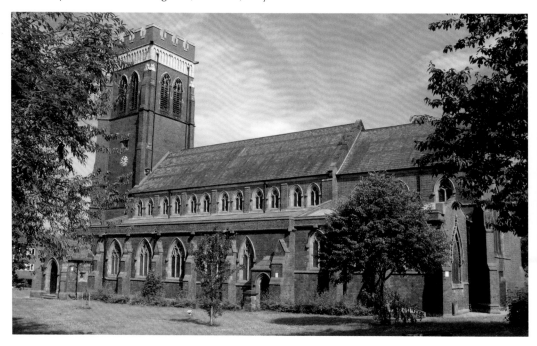

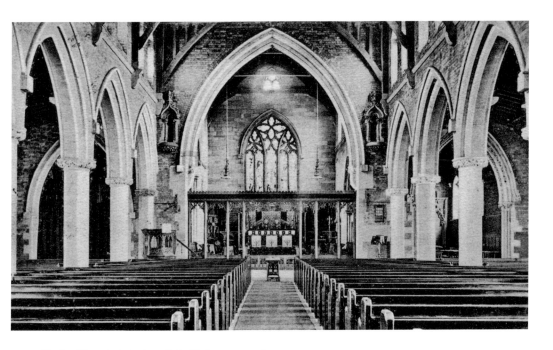

Christ Church Interior, Date Unknown and 2014
Christ church is noted for the outspoken sermons preached by the Red. Leonard Tyrwhitt in 1903, styled 'The Devil in the Potteries'. He criticised the 'appallingly immoral' atmosphere in the local china and earthenware factories. His proclamations triggered numerous angry letters in the *Sentinel* newspaper, including one from author Arnold Bennett, who regarded 'the theory that the Potteries as ultra-vicious is unworthy of discussion.' The Revd David Cameron is seen below.

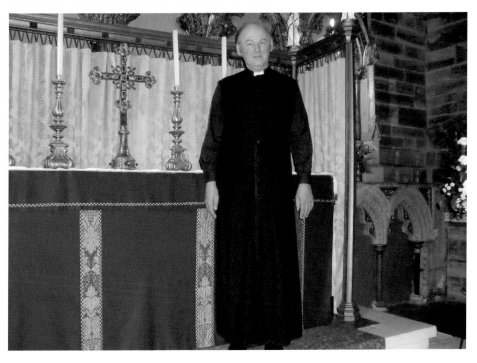

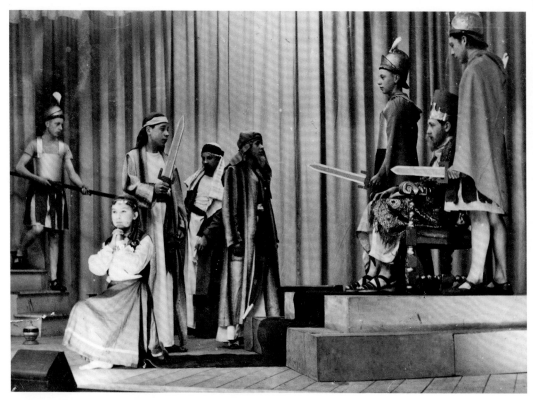

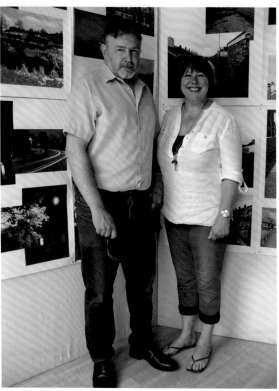

Nativity Play *c.* 1947 and The Gerrards, 2014

John Gerrard, the father of Alan (owner of Theartbay community art gallery), appears above. The venue is Queen Street School in Brocksford Street. Alan himself was born and bred in Fenton. The Gerrards have done much to re-emphasise awareness of the atrocity in Lidice, in 1942, when the Nazis retaliated for the assassination of Reinhard Heydrich by wiping out the Czech village. Alan and Cheryl have worked with schools, teaching the history of a village that was rebuilt partly through the efforts of North Staffordshire miners.

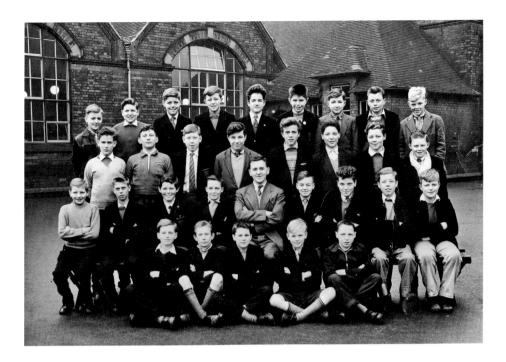

Schooldays, mid-1950s and 1994

Here is the school playground at Fenton County Secondary School for Boys. David Martin is on the third row, fourth from the right, with the horizontal-striped jumper. Formerly Queen Street Board School, it was opened as a mixed and infants' school. In 1932, it was reorganised to become Fenton C. S. Boys' School. In the 1960s, it became Fenton First and Middle School, before reverting to Queen's Primary in the early 1990s. These Brocksford Street buildings were demolished in 2008, following the construction of a new school nearby.

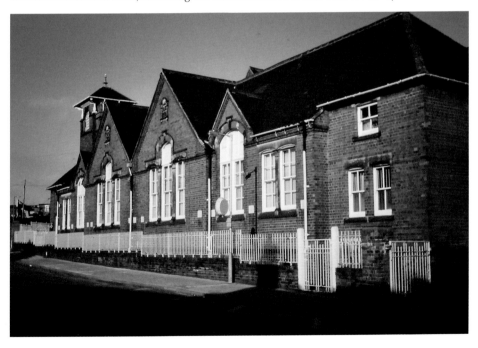

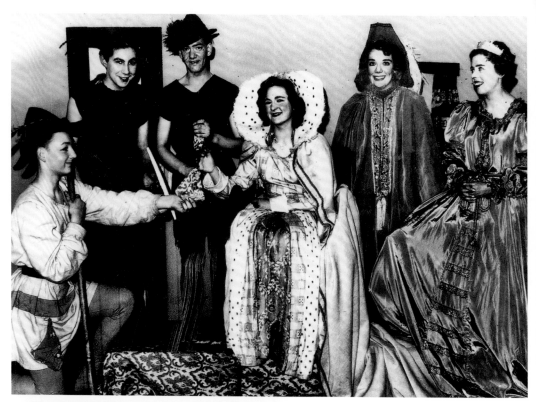

Fenton Combined Choirs, 1950s and Alan Mansell, 2013

Members of Fenton Combined Choirs are featured in the next five pages. These young entertainers came from Christ church, St Matthew's and St Michael's churches. Their headquarters was the church hall in Christchurch Street. Seen here are: Bill Robinson, Alan Mansell and Ann Mansell at the rear, and Barry John Hall, and Edna Day in the foreground. The play is *Babes in the Wood*. Alan Mansell was brought up in Fenton, worked in Longton in the 1960s, and is the author of two books, *The Original Longton Cottage Hospital* and *The Lost Liquor Licenses of Longton*. He was a consultant on Stoke Beerhouses, a short community film put together by Staffordshire University in 2013. Alan also appeared in a non-speaking acting role, and we see him dressed for the part (*below*).

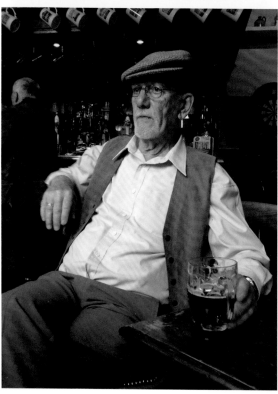

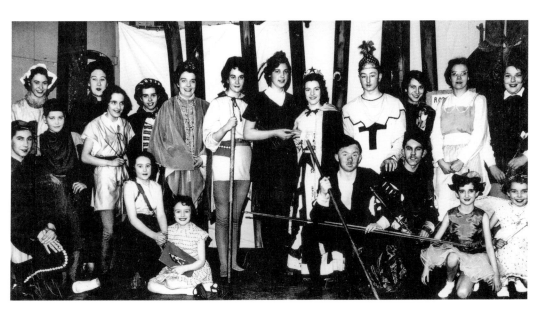

Fenton Combined Choirs, 1950s and Christ Church Doorway, 2014
This scene from *Robin Hood* shows a number of players, some of whom we have not been able to identify. However, known figures are Joyce Berrisford, Bill Robinson, Edna Day, Ann Mansell, June Hodgkinson, Jean Humphries, Mary Hall, Ann Jones, Marie Edwards and Glyn Ravenscroft. Among the architectural charms of Christ church is this handsome doorway (*below*).

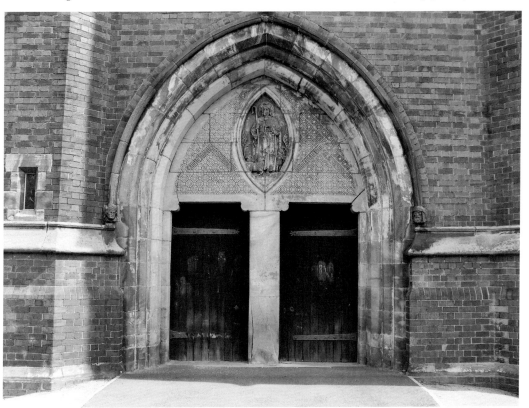

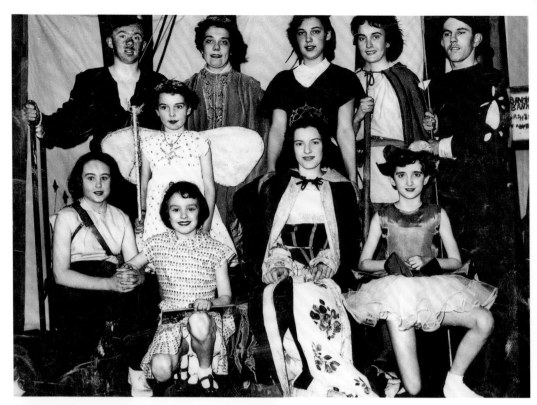

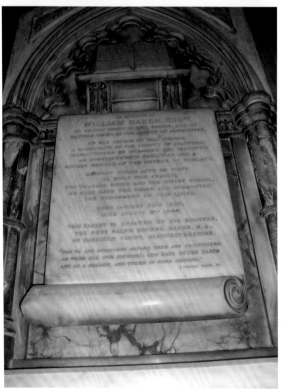

Fenton Combined Choirs, 1950s and William Baker Plaque, 2014

Another scene from *Robin Hood* features, Ann Mansell, Jean Humphries, June Hodgkinson, Glyn Ravenscroft (*back row*), whilst Marie Edwards is on the extreme left of the front row. The plaque in Christ church honours the name of William Baker (1800–65), pottery manufacturer. The Fenton improvement commissioners were established in 1839, and Baker became the first chief bailiff of Fenton, in 1840, remaining a serving commissioner until his death. He enlarged Christ church, which had been founded by his uncle, Ralph Bourne (died 1835). In 1861, he also became patron of the living in 1861. Among his other benefactions in Fenton were the infants' school of 1839 and a drinking fountain. In 1863, Baker bought a large estate, Hasfield Court, in Gloucestershire, though he had little time to enjoy it. He died, unmarried, in 1865.

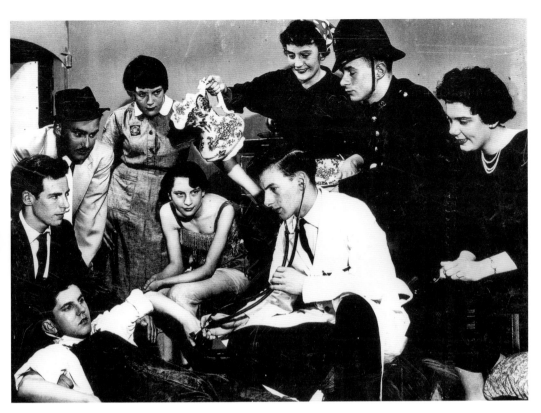

Fenton Combined Choirs, 1950s and Christ Church, 2014

A murder mystery play shows five figures on the back row: Terry Salt, Ann Jones, June Hodgkinson, Peter Jones, Ann Mansell. The middle three actors are John Salmon, Carl Moss, playing the doctor and Glyn Ravenscroft who is his patient. Christ church was built to seat 1,900 people. Its Gothic Revival style west tower was added in 1899. It has angled buttresses and a stair turret. Charles Lynam's other work includes the Villas in Stoke, Stoke-on-Trent free library and baths, the cemetery chapels at Hartshill, Stoke market complex and the Firs – a villa residence of 1855, now occupied by Newcastle Borough museum, on the Brampton, Newcastle. In the 1880s, Lynam erected what we now call St Peter's Arches in Stoke churchyard – a partial reconstruction of the pre-1830 church.

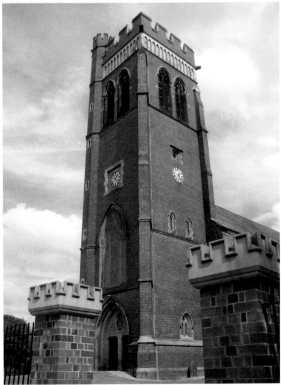

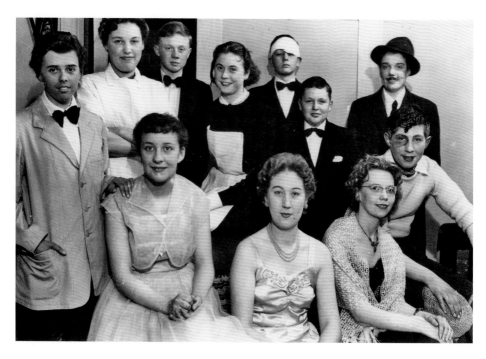

Fenton Combined Choirs, 1950s and Christ Church, 2014
Among the players featured in the murder mystery play (*above*) are Jean Humphries, Barry John Hall, Ann Mansell, Edna Day, Duncan Salt, Rita Laws, Joyce Berrisford and Bill Robinson. There are numerous gravestones of note in the churchyard, which include William Sollis, the first vicar of the parish. He held the post for thirty-three years and died in 1873. The oldest grave is that of Joseph Proctor of Fenton, who died in 1832, aged forty-three.

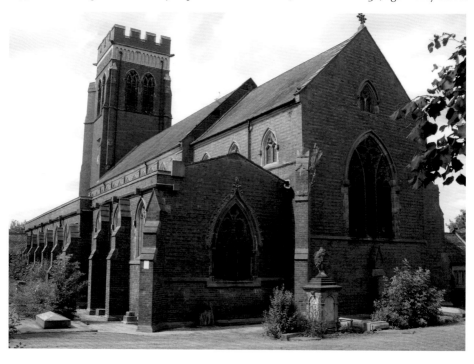

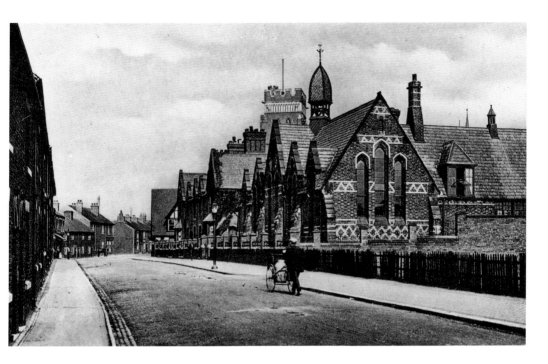

Christ Church Schools, Date Unknown and Christ Church Hall, 2014
The ornate church schools of 1867 are long demolished. In 1841, it was noted that one nine-year-old girl, from Fenton church Sunday school, could repeat from memory the first, second and eighty-fourth *Psalms*; the twelfth and fifty-third chapters of *Isaiah*; the third and twenty-fifth chapter of the first of *Corinthians*; the sixth chapter of *Ephesians*; the first, second and third chapters of *Hebrews*; and the whole of the church catechism. She had learnt all this in just over a year.

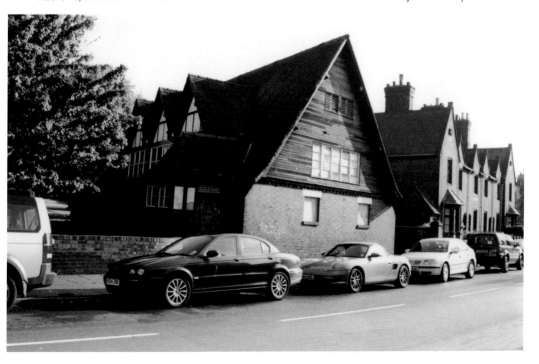

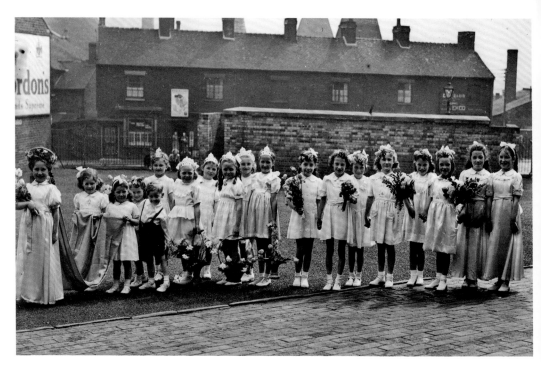

Turner Memorial School, 1943 and Demolition, *c.* 2005
Above we see carnival celebrations at the Turner Memorial School. Demolition of the school is taking place below, as seen from King Street. The school playground and Paynter Street are off to the right of the picture.

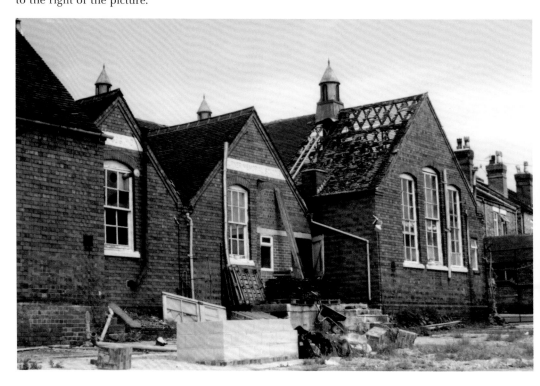

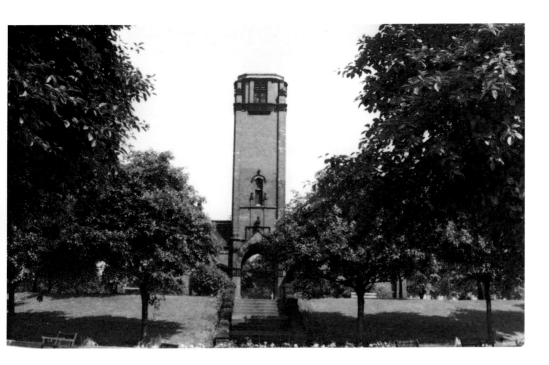

Cemetery Chapel, 1977 and Cemetery, 2014

Early photographs of Christ church show its adjacent graveyard. However, by 1856, restrictions were imposed on burials on account of diminishing space. Fenton Cemetery was one of the many municipal cemeteries that were established in order to address the lack of burial space in local churchyards. Fenton Cemetery, on the northeast side of the town, measured 16.5 acres and had burial ground on a sloping site. It was laid out in 1887 at a cost of £8,400.

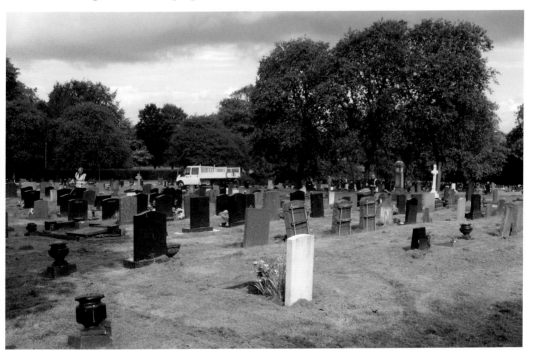

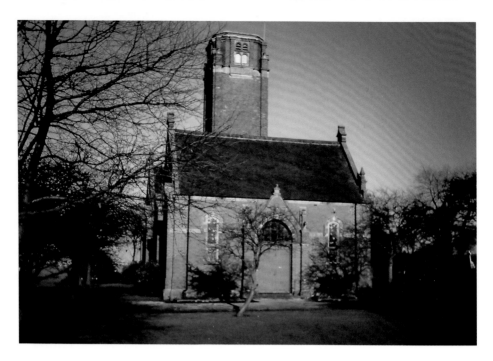

Cemetery Chapel, 1994 and Cemetery, 2014

In May 2001, the *Sentinel* newspaper announced that the cemetery chapel was to be demolished after council officials had declared it unsafe. It was said to have not been used for fifty years, and part of a ceiling had fallen down. A section of gable end wall had also collapsed. Though listed by the council as being 'of local importance', its position in the middle of Fenton Cemetery meant that its chances of being converted for alternative purposes were very slim.

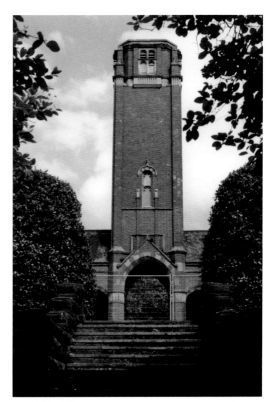

Cemetery Chapel, 2001 and Same Site, 2014
The chapel was finally demolished in
August, 2001. The stone steps remain in
situ, but much else has changed in Fenton
Cemetery, which is in close proximity
to Fenton Park. Both are used by people
wishing to take a stroll.

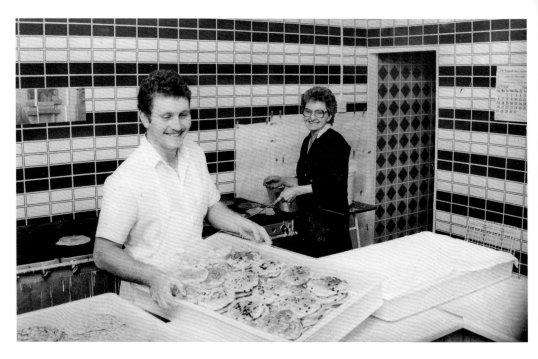

Bob's Oatcakes, Whieldon Road, 1980s and the Hungry Potter, 2014

Bob's Oatcakes and Pikelets was opened by Bob Newton, around 1985. Bob, a former policeman, began his new job on a government enterprise scheme. However, he began his new undertaking with plenty of accumulated knowledge. His parents, Frank and Betty, had run an oatcake shop in Heaton Terrace, Porthill. His new shop offered some novel fillings, including garlic, herb and chilli oatcakes.

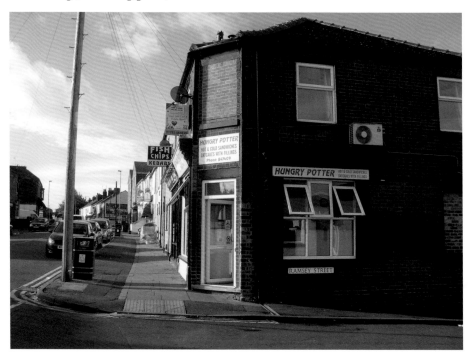

Bob's Oatcakes, 1980 and the Hungry Potter, 2014

Bob supplied the National Garden Festival, held in Etruria in 1986, with oatcakes. It was during a visit to the festival that Princess Anne purchased a dozen. Bob also sent oatcakes to a customer in South America, while another lady regularly rang him from Exeter for half a dozen, which even at the time cost over £5 in postage alone. Bob would usually begin his working day at 3 a.m., making the orders up for his regular customers. He recalls that he sometimes worked eighteen-hour days and, on some occasions, slept on a camper bed beneath his counter rather than go home. He sold the business in 1990, and it afterwards became known as the Hungry Potter.

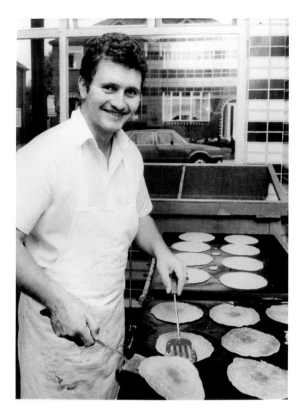

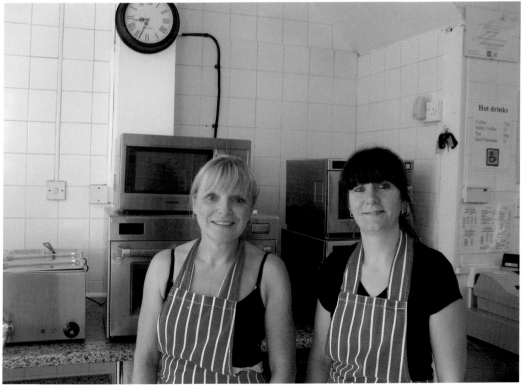

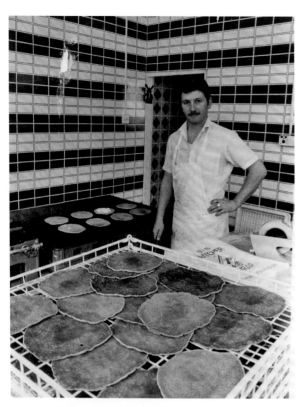

Bob's Oatcakes, 1980s and the Hungry Potter, 2014

Bob Newton now lives and works in Porthill, Newcastle-under-Lyme, but his old outlet still prospers. The Hungry Potter – a corner shop – presently trades on site at No. 147 Whieldon Road as an oatcake and sandwich bar. It is a short distance from the Trent & Mersey Canal and is therefore accessible to walkers and boaters. A little further up from the Hungry Potter, on the same side of Whieldon Road, is the 1930s-built Regent public house, a former Parker's Burslem Brewery pub and one of the finest pub buildings in Fenton.

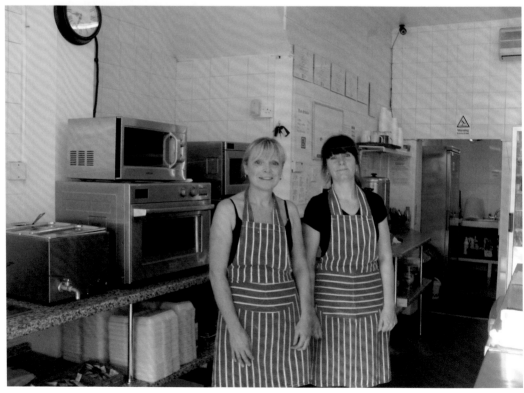

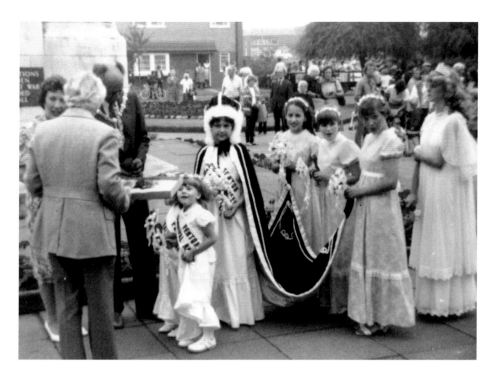

Carnival, 1984 and Similar Scene, 2014

Fenton's carnival queen and her retinue appears here, as well as Doug Brown, the lord mayor of Stoke-on-Trent. Doug was born in 1922. His father emigrated to England from the Gold Coast (now known as Ghana) in West Africa. Doug was educated in Hartshill, and during the Second World War he was trained as a physiotherapist, helping the recovery of injured soldiers. In 1960, he became Stoke City's club physiotherapist.

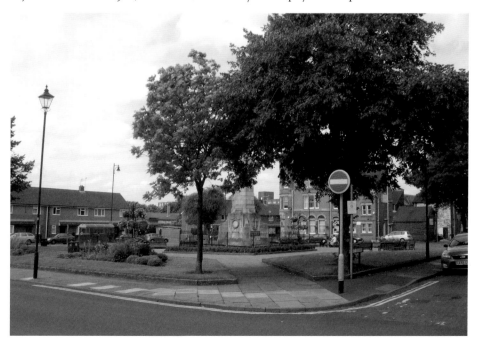

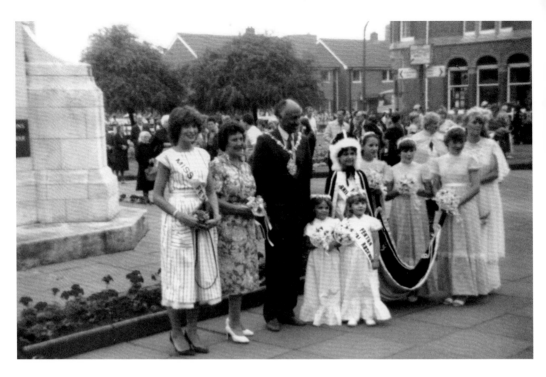

Carnival, 1984 and Similar Scene, 2014

In 1967, Doug Brown was elected as an independent councillor for the Hartshill ward, though he later joined the Labour Party. He was very involved with the local lads and dads football scheme, and was nominated by local footballers, Garth Crooks and Robbie Earle, for the BBC People's Awards. He was elected to the office of lord mayor in 1983/84, and again in 1997/98.

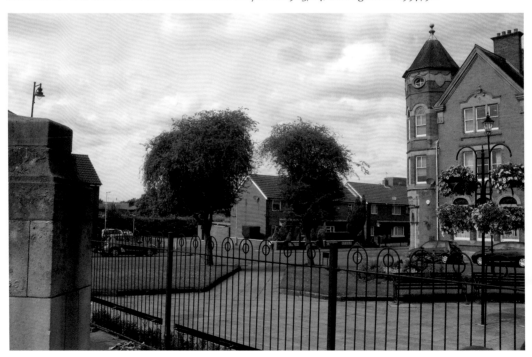

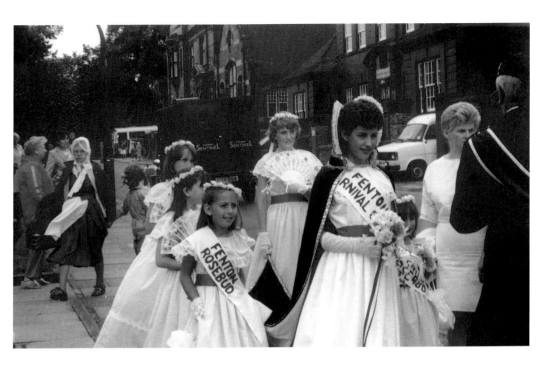

Carnival, 1984 and Similar Scene, 2014

Fenton Carnival has continued to be held in recent years, thanks to support from bodies such as the community group, DASALYN, Christ church Primary School and Kemball Special School, sometimes offering bizarre attractions. In 2011, a 15-feet street puppet of Poseidon, operated by Christ church parents, led a procession through the streets. A giant octopus, attached to the wheelchair of one of the Kemball students, also made an appearance.

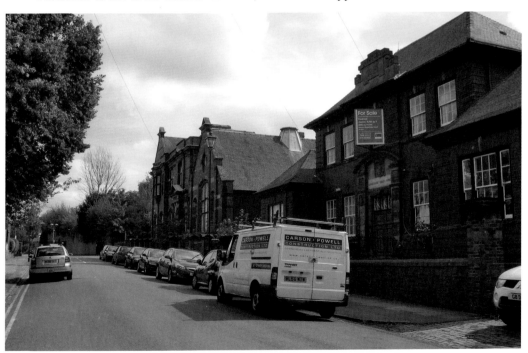

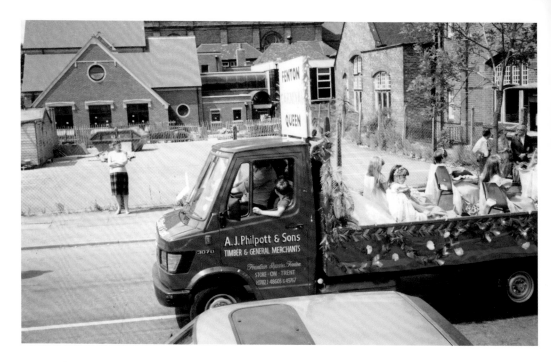

Carnival Philpott's Truck, 1984 and Similar Scene, 2014

The above view shows the involvement of a local trader, A. J. Philpott and Sons Ltd, in the 1984 carnival. The timber and general merchants, established in 1919, continue to trade in Fountain Street, Fenton, selling power tools, ironmongery, heaters and even rock salt. In June 2014, Peter Philpott, the present director of the family firm, expressed fears in the local press that Stoke-on-Trent City Council's focus on Hanley was having a detrimental effect on smaller businesses in Fenton and elsewhere.

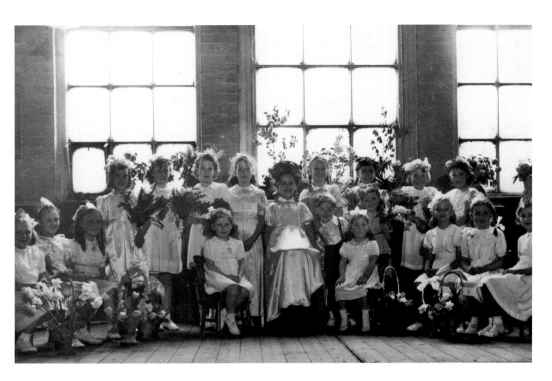

Children Over the Years

Pretty children and pretty flowers make pictures to remember – as this proves. The colour photograph is contrasted with a May Day celebration at the Turner Memorial School, in Fenton, dated 1949.

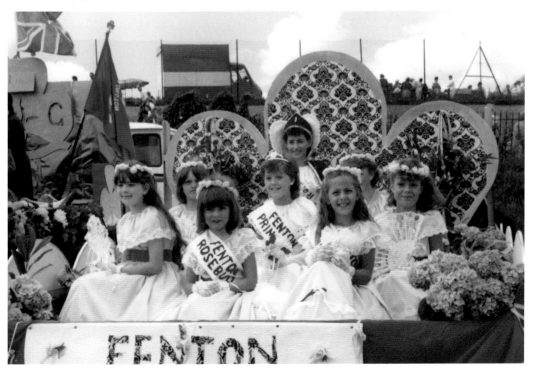

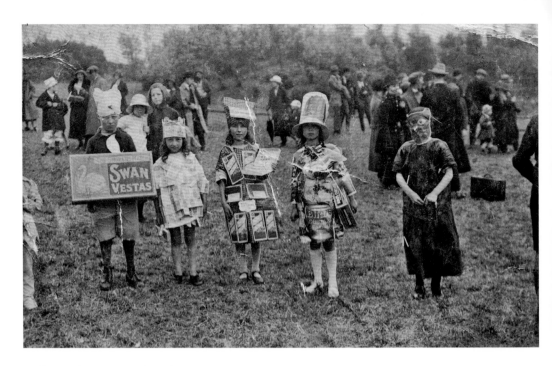

Park Opening, 1924 and Park, 2014

The land for Fenton Park was purchased in April 1912 from Messrs Warrington & Son Ltd. Henry Warrington and his offspring were colliery and brickwork proprietors who lived at Fenton Manor. Public interest in the project was stimulated, in 1914, when rough sketches were discussed. However, the First World War and other factors were to ensure that the park would not open until 1924, but the rare image (*above*) captures a scene from a key event in Fenton's history.

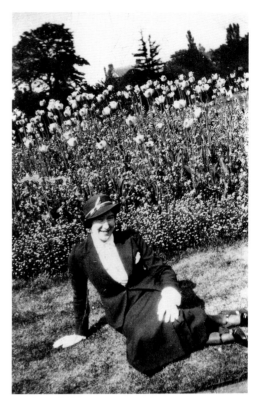

Park and Young Woman and Park, 2014
The land on which the park was laid out
had been transformed from what was
described as 'a desolate waste, of which
a colliery tip was the most prominent
feature.' Civic dignitaries met in Fenton
town hall to enthuse over the newly opened
park. Fenton's population at this time was
27,000, and at the town hall there was much
discussion – some of it tongue-in-cheek –
about what Fenton had and hadn't got. One
speaker declared: 'Whatever Fenton might
lack in social amenities and so forth, it was
the most luckily situated town in north
Staffordshire in that it was so very near to
Stoke (laughter). There, they had everything
they wanted and practically on their doorstep
(renewed laughter).'

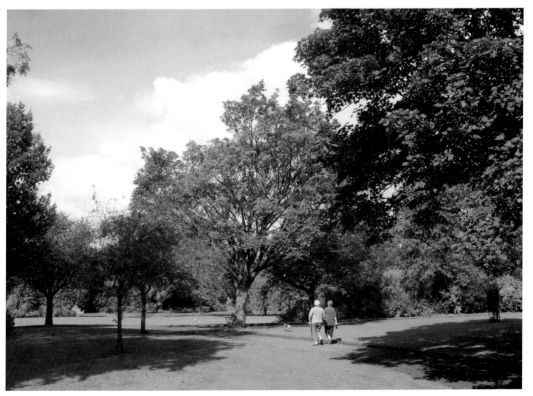

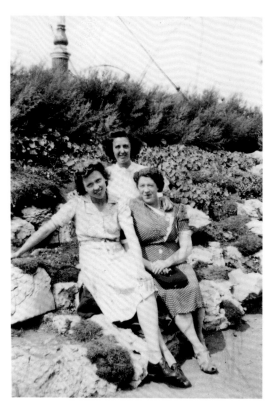

Park and Three Women and Park, 2014
Local men undertook the difficult reclamation work on the park. It was also mentioned at the time of the opening that this part of town was made up of much working-class housing. Planting was quite extensive, with 8,000 trees and shrubs adorning the 17 acre park. Upon opening, the park offered two bowling greens, tennis courts and playgrounds, with other amenities envisaged for a future time. In the 1950s, extensions were added to the park, embracing football pitches, an area for cricket, a changing pavilion and a rockery. The new facility – now 35 acres in extent – was officially opened in 1959, by Lord Mayor Alderman Harold Clowes, who had grown up in the Fenton district.

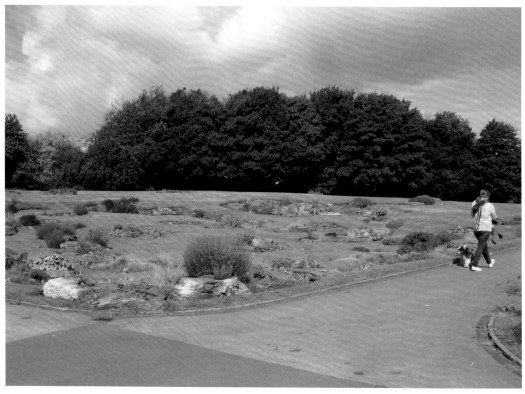

Relaxing in the Park and Park, 2014

In March 2012, The *Sentinel* newspaper was able to report that over £450,000 had been spent on revamping what is a relatively low-maintenance park. The football pitches and changing rooms have been improved. The modern scene shows part of the rockery at Fenton Park. This was constructed using Yorkshire limestone during the late 1950s by Bill Jackson, who later became the director of the city's parks department. Among the flowers planted around the rockery were snowdrops, daffodils and tulips. Frogs, newts and toads are known to use the rocks to hide in the shade during the summer months. Swallows are a common sight in the park.

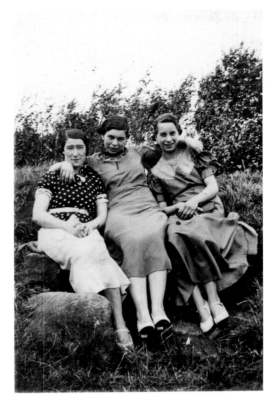

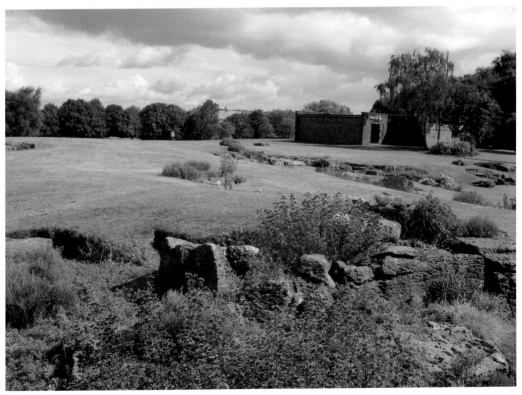

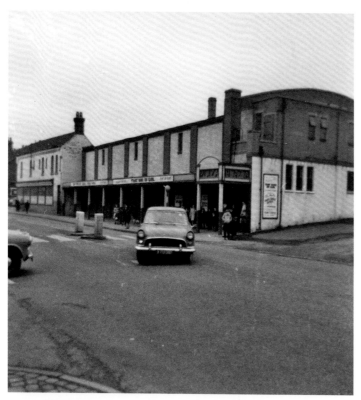

Plaza Cinema, 1964 and Plaza Snooker Club, 2014
September 1910 saw the opening of Barber's Picture Palace in what was then Market Street, Fenton. An advertisement brashly declared that everything was 'slap bang up-to-date.' It added that 'plush seats are provided in front, leather seats behind at sixpence, upholstered seats at fourpence.' The cinema later became the Plaza.

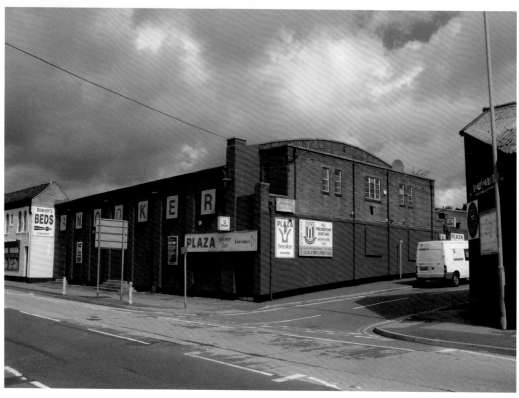

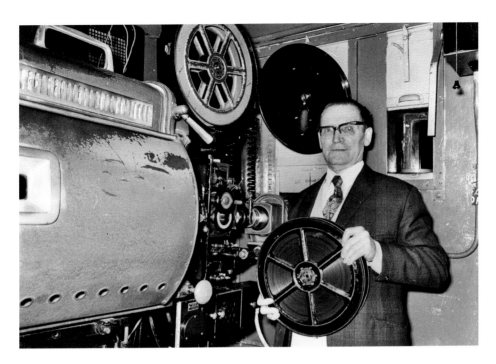

Benny Norcott, 1979, Plaza Snooker Club from Rear, 2014 and David Rayner (*inset*)
From 1948 until the closure of the cinema, in 1982, the manager was Benny Norcott, whose wife was George Barber's granddaughter Maisie. David Rayner, a renowned authority on north Staffordshire cinemas, worked at the Plaza as a projectionist. He recalled that the cashier, Connie Gerrard, and her mother, often began cleaning the cinema at six in the morning. The building later became a snooker club.

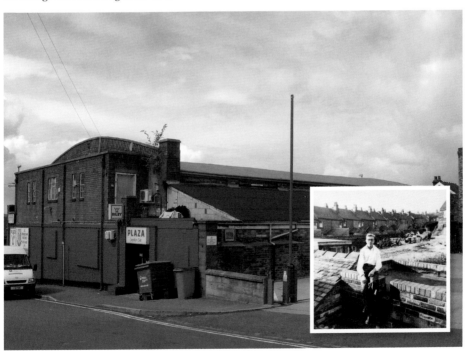

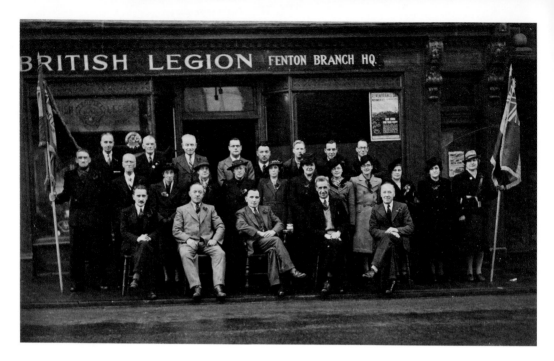

Drinkers in Fenton, Date Unknown and 2000

Our section on watering holes begins with a look at the old British Legion Club in Fountain Street. In May 1947, the Fenton branch of the British Legion staged a dance at the town hall, supported by Jimmy Moss and his band. The local press advertised: 'A good time is always had at a Legion dance. Admission 2s 6d. Forces in Uniform 1s 6d. Support an Ex-Servicemen's Effort.' Drinkers in more modern times are seen at the Malt and Hops in 2000.

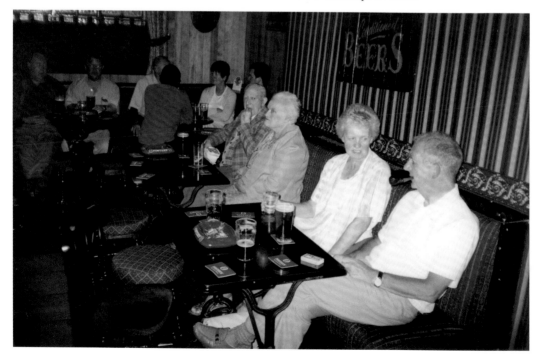

Drinkers in Fenton, Date Unknown and 2000

This old chap poses outside the Albion Pub. Below shows landlord Len Turner pulling a pint at the still trading Malt and Hops. Fenton has lost many much-loved pubs. Among the historic hostelries that have disappeared are the Roebuck, the Old Black Swan, the Cross Keys, the Dog and Partridge and the Canning Inn. Others, such as the Foley Arms Hotel, stand derelict at the time of writing. In 2013, planning permission was given to convert the Queen Victoria pub in Victoria Road into private accommodation. Perhaps the town was more appealing to people of previous generations; a report in the local press of 1893 conveys that one inmate escaped from Stoke Workhouse and subsequently got drunk in Fenton.

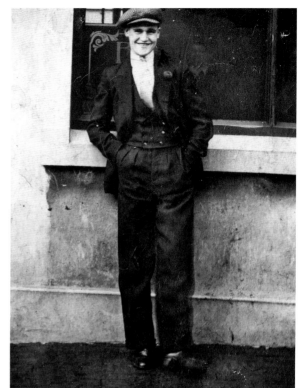

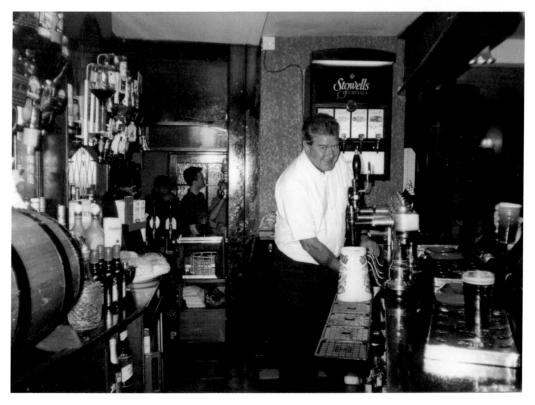

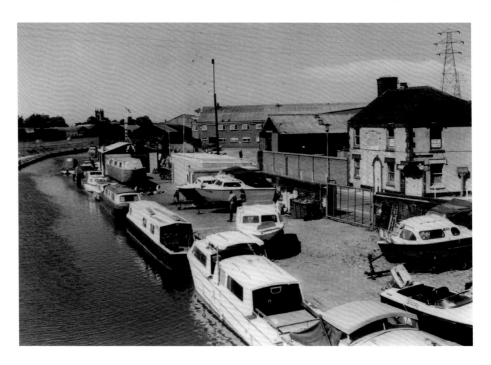

Bird in Hand, 1983 and Approximate Site, 2014
The Bird in Hand pub (*top-right*) stood on Old Whieldon Road at the junction with Talbot Street (later changed to Kerr Street), and was in the borough of Fenton. The name of Old Whieldon Road was given to this road after Whieldon Road, from Mount Pleasant, was redirected to run to Church Street, Stoke, over the canal bridge. In the foreground are the Trent & Mersey Canal and boatyard, taken from the Whieldon Road Bridge, Fenton.

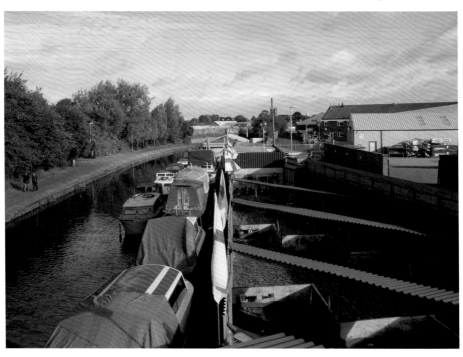

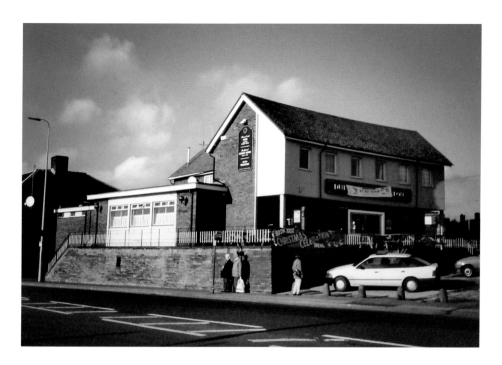

Duke of Wellington, 1994 and 2014

This pub's predecessor on site was given the address of Market Street in the old trade directories. The present building, in what is now King Street, opened in 1963, built by Bass, Ratcliff and Gretton Ltd. At the time, it incorporated the Potters Bar and the Fenton Lounge. It also incorporated an enormous beer cellar of nearly 100,000 bricks. The managers at the time were Mr and Mrs J. V. Marshall.

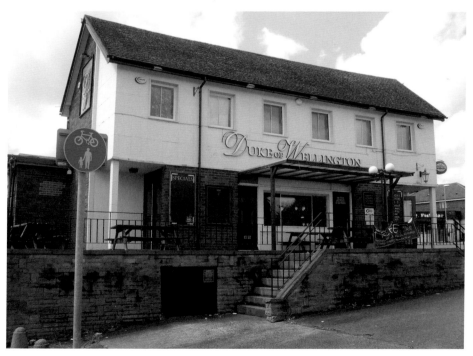

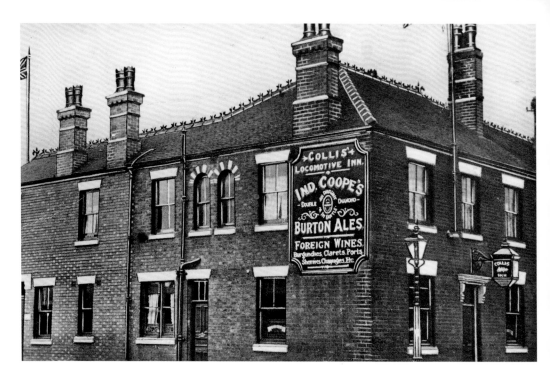

Locomotive, Heron Cross, Date Unknown and 2014

Both the locomotive and the railway below it pay homage to the Fenton railway station that once stood below, on the north Staffordshire railway line. The present pub boasts of a lounge and a bar. Note the wind-resistant pub sign, overlooking Heron Street.

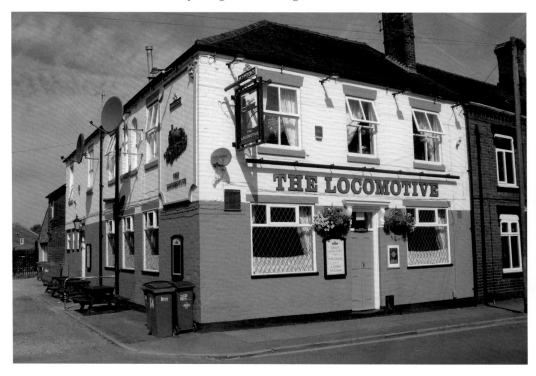

84

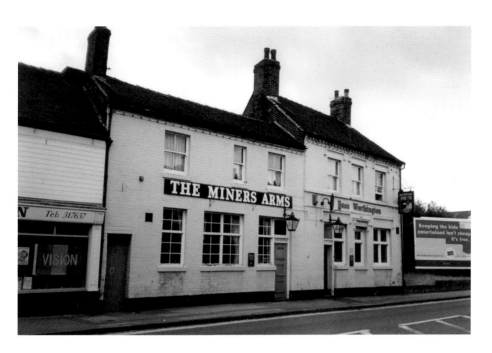

Miners Arms, 1998 and 2014

These two contrasting scenes show an open and closed Miners Arms in King Street. During the intervening period, this was a pub that knew many vicissitudes. In 2004, landlord Mario Lowndes was forced to close the pub on account of a mystery smell that rendered his beer undrinkable. They claimed that the stench was coming from sewers beneath the premises, though Severn Trent Water responded that they were unable to find the source of the problem.

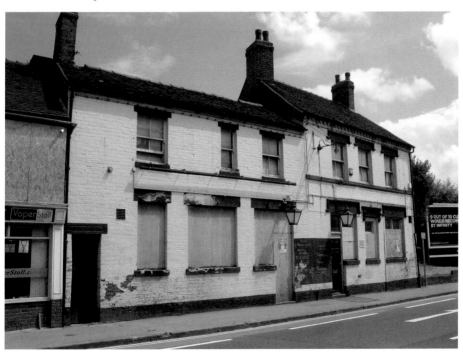

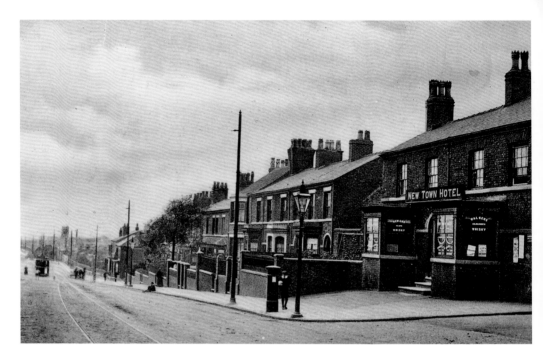

Newtown Hotel, Date Unknown and 2014

St Peter's church, Stoke, is seen in the distance (*above*). An idea, hatched in the Newtown Hotel in 1954, provoked a charity fundraising effort. Customers over the age of forty at the Newton claimed that they could beat the younger men at football – with the result that the Newtown Rangers challenged Fenton Youth Club to a game on the Smithpool Road ground, and beat them 5-4. About £30 was raised for Fenton OAPs Association.

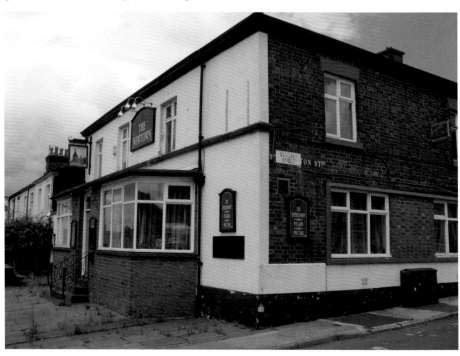

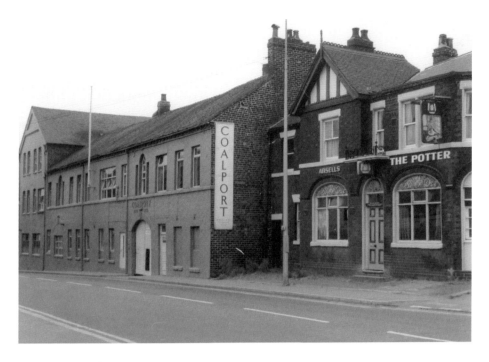

Potter, 1977 and 2014

The Potter in King Street was originally the Railway Hotel. Left is Coalport China, originally the Old Foley Pottery of James Kent Ltd. Later acquired by Coalport China (established 1750), it was demolished in 1995. The Old Foley Pottery was also in use between 1872 and 1892 by Moore & Co., and in use by Moore, Leason & Co. between 1892 and 1896. Waste ground is now to be found to the left of the pub.

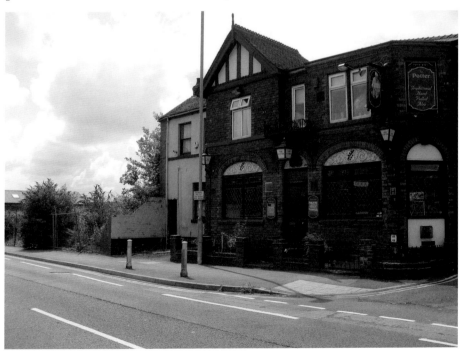

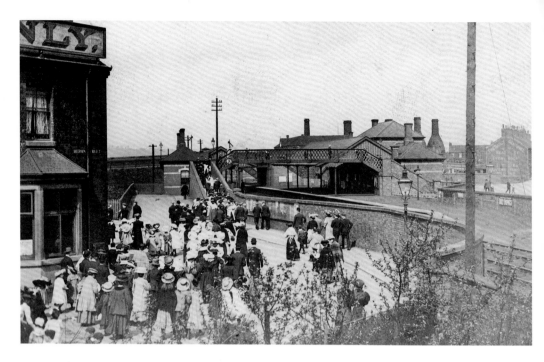

Railway and Railway Station, *c.* 1908 and Railway, 2014

The Railway pub at Heron Cross creeps into the left, which shows a procession by the Mount Tabor Sunday school. Fenton railway station is seen in the background. Historically, the pub – often referred to as the Railway Hotel – derived much custom not only from those people using the adjacent Fenton station, but also from visitors to the cricket ground to its rear.

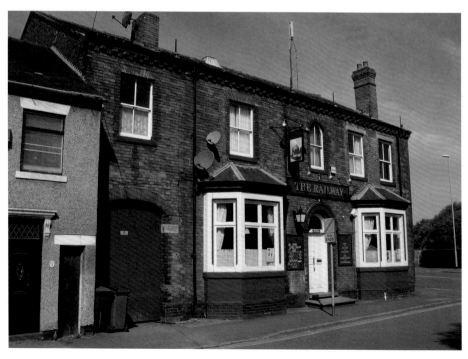

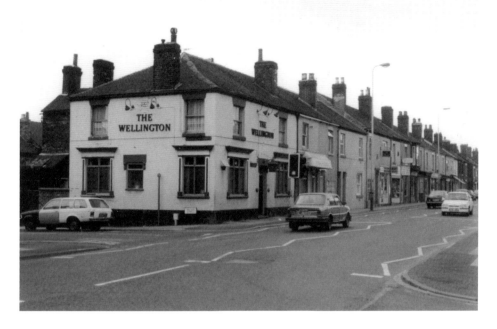

Wellington, 1988 and Darcy's, 2014

This pub was originally the Wellington Inn, Victoria Road, standing at the junction with William Street, left. In 1991, it became the Foaming Tankard in 1991, after the Wellington Inn closed in 1990. When the Foaming Tankard ceased trading, in 2012, it reopened as Darcy's. When operating as the Wellington Inn, in the 1950s, it was known locally as D'Arcy's, due to the landlord being Mr Stephen D'Arcy, who is listed in the Potteries and Newcastle District Directories of 1907 and 1912.

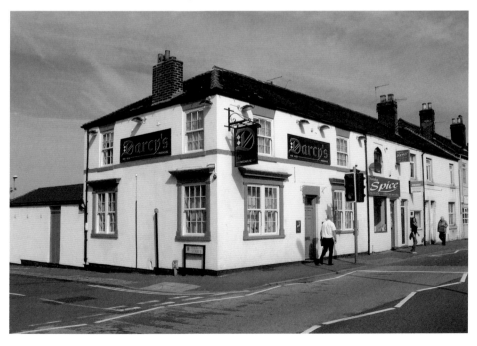

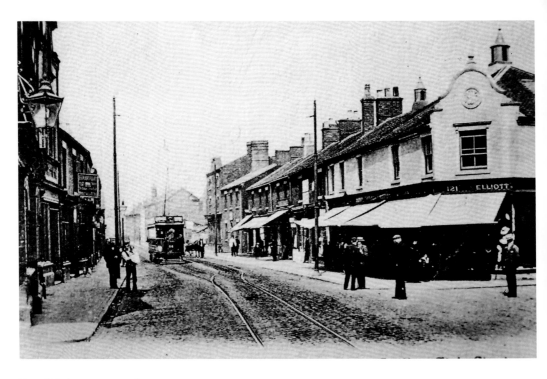

Royal Oak, *c.* 1903 and 2014

This postcard image, postmarked 1903, shows the Royal Oak, the address of which was then High Street. The pub is seen on the far left, on the corner of Church Street, now Christchurch Street. Elliot's Drapery is the large building at the end of Manor Street, whilst F. & R. Pratt's earthenware manufactory is located in the middle.

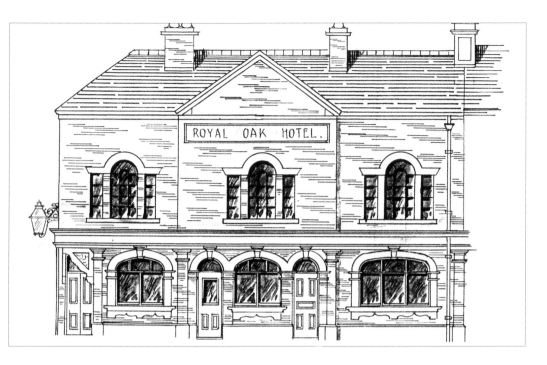

Royal Oak on Architect's Plan, 1911 and 2014

The Royal Oak's three Venetian windows and its handsome pedimented gable are prominent features on this 1911 plan. Data in the author's possession includes indentures of lease, dated 1809, referring to Francis Mould as a farmer and victualler. Information in the Enoch Wood Collection confirms that he was keeping the Royal Oak in 1810. In November of that year, an auction of potworks, dwellings and shares in the Fenton Park and Goldenhill Collieries was held at the inn.

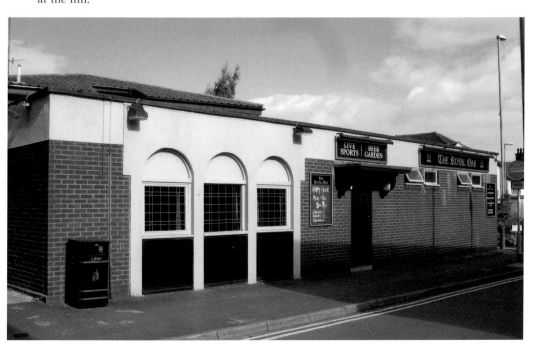

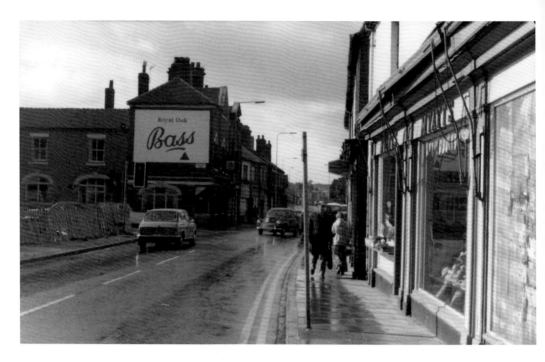

Royal Oak on City Road, 1977 and Same, 2014

Francis Mould's will (dated 13 August 1825) reveals that his public house had a brewhouse, barn, cowhouse, stableyard, garden and other appurtenances attached. The Mould family continued their association with the pub for many years. The rebuilt Royal Oak, of 1981, was considered pleasing enough to be included in the CAMRA Potteries 1984 brochure, *Real Ale In And Around The Potteries*.

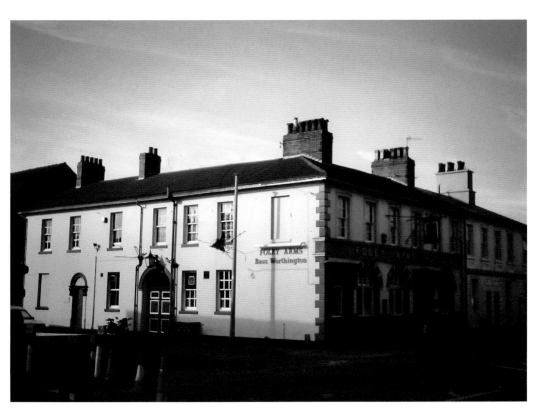

Foley Arms, 1997 and 2013

Julie Hill, of Fenton, wrote to the *Sentinel* newspaper, in 2012, recalling that the Foley Arms had a men-only bar up until the mid-1970s. Jack Eagles, whose father had been the landlord previously, ran it. Julie recalled, 'having finished on the twilight shift at Coalport factory on a Friday night and dared to enter the bar, you would be stopped before getting a foot in the bar, and sternly told, "Ladies not welcome, go round to the back room." The back room was more genteel, with couples enjoying a night out nearly every night, not just weekends. In the outdoor department, a barmaid was needed until 9.30 p.m. to fill the overflowing stream of take-outs. Dads and mums would come in for a pint and stand in the outdoor area with their children, who would have a bag of crisps and an orange cordial – on the house of course.'

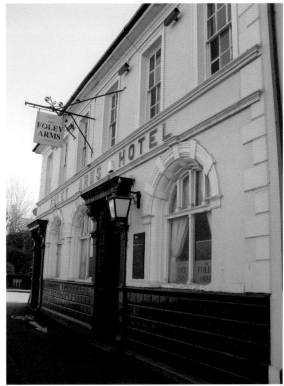

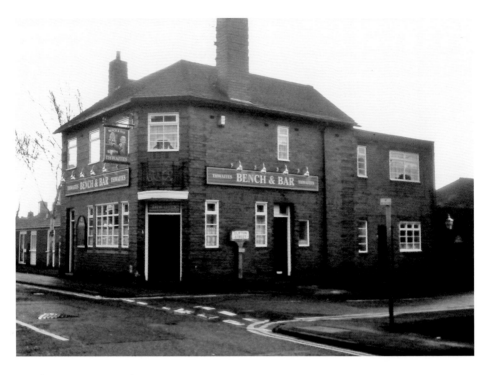

Bench & Bar, 1997 and 2014

This pub's name alludes to the nearby town hall's spell as Fenton magistrates' court. This relocated to Newcastle in December 2012. In July 2013, following a refurbishment, the Bench & Bar was reopened as a free house.

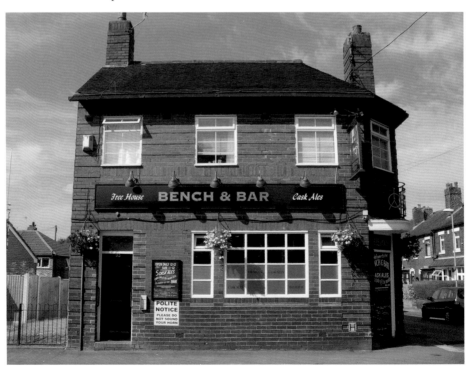

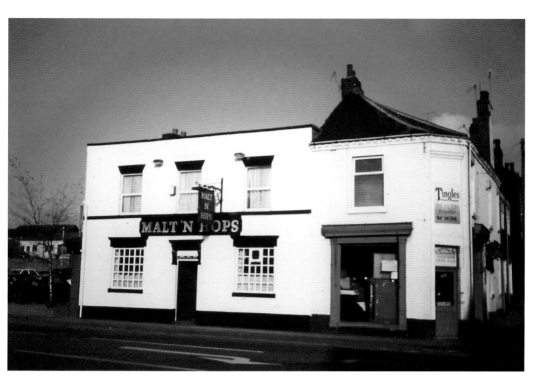

Malt and Hops, 1994 and 2014
Formerly the Red House, the Malt and Hops won the CAMRA Potteries branch North Staffordshire Pub of the Year award in 1992. The licensees at the time were Len and Alice Turner.

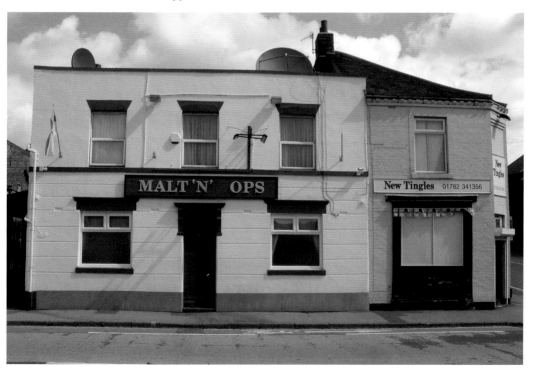

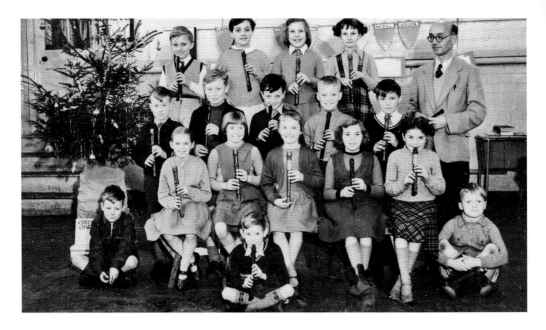

Market Street Board School, *c.* 1955
It's back to school for our final scene. Market Street Board School was built in 1872. Its name changed to Glebe County Junior School, in 1955, to reflect the road name changes that took place in the Potteries in the early 1950s. Market Street changed its name to King Street. This picture shows a music class, preparing their recorders for a carol concert.

Acknowledgements

Special thanks go to Alan Salt, Mr and Mrs Priestley, and Alan and Cheryl Goddard of Theartbay gallery in Fenton, without whose generous help this book may not have been published. Also, Steve Birks, Margaret Bould, Carol Brown, Keith Brown, Ruth Buckley, Evelyn Cope, Ken Edwards, the Gladstone Pottery Museum, Marie Haywood, Alan Mansell, Alan Massey, Keith Meeson, Doug Millington, Bob Newton, Cliff Proctor, Elizabeth Quinn, David Rayner, the *Sentinel* newspaper, Fay Toft, Gary Tudor, Dave Walklett, Keith Warburton and Jim Worgan. Thanks also to the numerous Fenton people who supplied photographs for an exhibition at Theartbay, from which some of this book's images were taken.

Every effort has been made to correctly identify copyright owners of the photographic material in this book. If, inadvertently, credits have not correctly been acknowledged, we apologise and promise to do so in the author's forthcoming title for Amberley Books.

The above people personally supplied much caption information. Readers are asked to allow for minor errors of memory.